IMAGES
of America

HULL-HOUSE

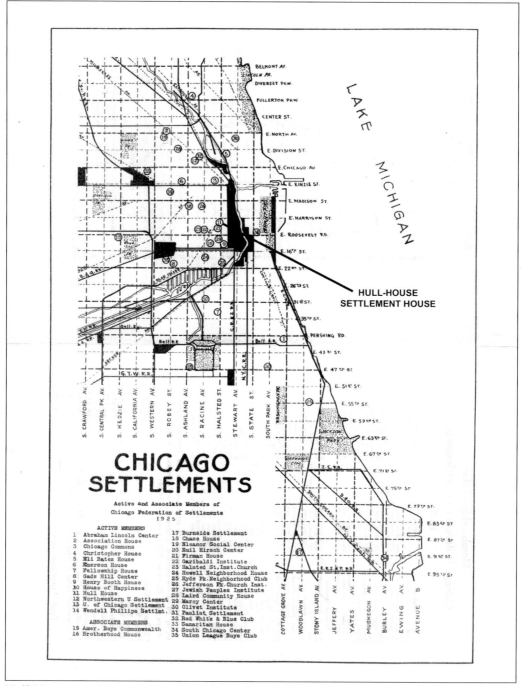

Hull-House was the most prominent of the many Chicago settlement houses established in the late 19th and early 20th centuries. This adaptation of a 1925 map shows the location of members of the Chicago Federation of Settlements and Neighborhood Centers. (CFSNC)

IMAGES
of America

HULL-HOUSE

Peggy Glowacki and Julia Hendry

ARCADIA

Published by Arcadia Publishing
Charleston SC, Chicago IL, Portsmouth NH, San Francisco CA

Printed in Great Britain

Library of Congress Catalog Card Number: 2004111311

For all general information contact Arcadia Publishing at:
Telephone 843-853-2070
Fax 843-853-0044
E-mail sales@arcadiapublishing.com
For customer service and orders:
Toll-Free 1-888-313-2665

Visit us on the internet at http://www.arcadiapublishing.com

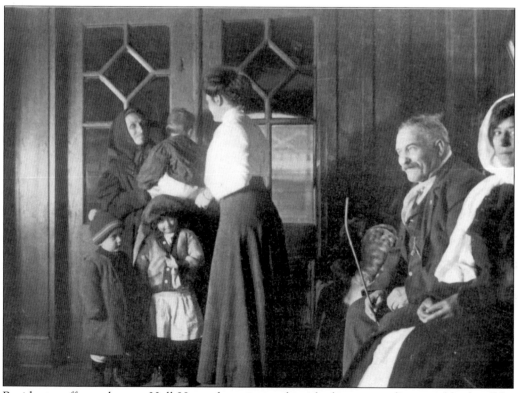

Resident staff members at Hull-House kept in touch with the surrounding neighborhood by taking turns welcoming their neighbors at Hull-House's front door. (JAMC 5571)

CONTENTS

ACKNOWLEDGMENTS

The support of the University of Illinois at Chicago Library, especially Gretchen Lagana, Patricia Bakunas, Douglas Bicknesse, and Mary Diaz of the Special Collections Department, made this book possible. We are also indebted to Don Hendry, Tom Perrin, and Professor Patricia Mooney-Melvin for their insightful comments on the text and Howard Hart for his advice on the selection of photographs. Special thanks to both Howard and Tom for listening to endless stories about Hull-House when they really just wanted to watch the ballgame.

The majority of photographs used in this book are from the Jane Addams Memorial Collection (JAMC) in the Special Collections Department, University Library, University of Illinois at Chicago. Other collections used from the Special Collections Department, University of Illinois at Chicago are: Wallace Kirkland Papers (Kirkland); Chicago Federation of Settlements and Neighborhood Centers Records (CFSNC); Art Resources in Teaching Records (ART); Mary Crane League Records (MCL); Rare Book Collection (RBC); Hull-House Association Records (HHA); Institute for Sex Education Records (ISE); Bertha Schlotter Papers (Schlotter); Esther Saperstein Papers (Saperstein); Florence Scala Papers (Scala); Bethlehem–Howell Neighborhood Center Records (BHNC); Italian American Collection (IAC). Abbreviations for photograph and manuscript collections are used in the text.

Photographs from several books in the Lawrence J. Gutter Collection of Chicagoana in the Special Collections Department, University Library, University of Illinois at Chicago were also used. They are referenced by author in the captions.

Chicago Commission on race Relations. *The Negro in Chicago*. Chicago: University of Chicago Press, 1922.

The Child in the City: A Handbook of the Child Welfare Exhibit at the Coliseum, May 11 to May 25, 1911. Chicago: Blakeley Printing Co., 1911.

Dewey, John. *The School and Society*. Chicago: University of Chicago Press, 1900.

"The Fight for Pure Milk." *Life and Labor* 2 (October 1912).

Hunter, Robert. *Tenement Conditions in Chicago*. Chicago: City Homes Association, 1901.

Norton, Grace Peloubet. "Chicago Housing Conditions, VII: Two Italian Districts," in *American Journal of Sociology* 18 (January 1913).

Residents of Hull-House. *Hull-House Maps and Papers*. New York: Crowell, 1895.

Swinton, John. *A Momentous Question: the Respective Attitudes of Labor and Capital*. Philadelphia: A. R. Keller, 1895.

Tobenkin, Elias. "The Immigrant Girl in Chicago," in *Survey* 23 (1909-1910).

The Traffic in Girls: White Slavery as now Practiced in America. Chicago, c. 1900.

Zueblin, Charles. *A Decade of Civic Development*. Chicago: University of Chicago Press, 1905.

INTRODUCTION

In a 1904 investigation of American cities, journalist Lincoln Steffens described Chicago as the city "first in violence, deepest in dirt; loud, lawless, unlovely, ill-smelling, [and] irreverent." In 1889, when two wealthy young women, Jane Addams and Ellen Gates Starr opened Hull-House, Chicago was on its way to becoming the transportation hub of the nation and the greatest grain market, lumber market, and meat-packing center in the world. From 100,000 inhabitants, industry had spurred population growth to over one million in just three decades. Composed largely of immigrants from Europe, the population would double again by 1910. The phenomenal growth made the Chicago of the wealthy a community brimming with political and economic opportunity. The Chicago of the poor, however, was one of wretched conditions, and few opportunities to get ahead.

Hull-House was hardly the first attempt by wealthy women to help the working class immigrants of Chicago. As the United States struggled with change from a rural, agricultural economy to an urban, industrial one, middle class citizens fretted over the frightening changes they saw taking shape. Urbanization, immigration, and industrialization signaled progress and prosperity but also struck fear in the minds of those convinced the social fabric would be rent by the rapid changes that were occurring. Addressing these issues became the focus of debate and discussion. Concerned citizens responded with traditional charitable endeavors designed to address catastrophe or temporary crises. But their efforts were clearly inadequate for the deep-rooted environmental problems that plagued the modern city.

Co-founders of Hull-House, Jane Addams and Ellen Gates Starr's insistence that they must live among the poor to learn first-hand the problems of their neighbors and to establish personal relationships with them was a radical departure from established forms of philanthropy. Inspired by the world's first settlement house, London's Toynbee Hall, Addams and Starr rented an old mansion on Halsted Street in the midst of one of Chicago's most congested immigrant neighborhoods and made it their home. For Addams, "settling" in a working class neighborhood was not merely an effective way to help the poor, it was a response to what she perceived as the polarizing effect of urban industrialization on American society. Sub-standard living conditions and exploitative labor practices threatened the very system of American democracy by restricting the political, social, and economic opportunities of the working class and setting up antagonistic relationships between classes, ethnic groups, and genders, argued Addams.

The settlement house responded by establishing a space in which dialogue could occur, concrete techniques for coping with the modern city could be explored, and understanding, respect, and tolerance fostered.

Soon, other young, educated women and men joined Addams and Starr as 'residents'—social

reformers who lived at the settlement house and worked both to improve the immediate conditions of the neighborhood and to eliminate the causes of despair. Energetic, idealistic young women, in particular, were drawn to Hull-House. The settlement provided an alternative living space within the city that allowed independence but also the support and companionship of like-minded people. In an era when women's roles were severely restricted, Hull-House offered opportunities for women to emerge into public life as leaders, teachers, social investigators, activists, and organizers.

By the first decade of the 20th century, Hull-House had grown from a modest house to a massive complex serving thousands of people every week. From their vantage point on Halsted and Harrison, Hull-House residents witnessed many changes. They saw waves of migrants arrive in Chicago, first from Europe, then Latin America and the American South. They suffered with their neighbors through periods of war, economic depression, and xenophobic hysteria. And they celebrated the significant artistic, academic, athletic, and economic achievement of many settlement participants. Hull-House residents could congratulate themselves in securing legislation aimed at providing opportunities for and protecting the rights of the working class. Most importantly, their ideas on the systemic problems of the city changed perceptions of the urban environment for future generations.

The principles that guided their early efforts made Hull-House into a model for the over 400 settlement houses established near the turn of the century and sustained its longevity into the 1960s, when the buildings were torn down to make way for the new campus of the University of Illinois at Chicago. As they worked to eliminate the root causes of poverty and alienation and to provide opportunities to the disenfranchised, Hull-House sought to foster meaningful relationships across class, ethnic, and gender lines. They were driven by the belief that all society would ultimately benefit when democracy fulfilled its true potential. Today, Hull-House's experiment with democracy continues to provide a model for the programs of the Jane Addams Hull House Association and to offer important lessons on the political, social, and economic dimensions of social justice.

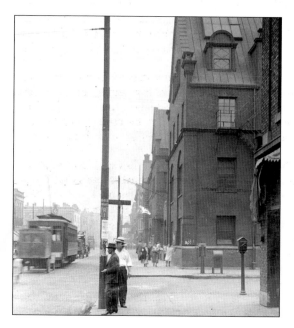

The 13-building Hull-House complex fronted Halsted Street, a busy commercial thoroughfare on the Near West Side of Chicago. This view looking south towards the settlement shows the Smith building at the corner of Polk and Halsted Streets. (Kirkland)

One

HULL-HOUSE
OPENS ITS DOORS

In July 1889, Jane Addams and Ellen Gates Starr opened the doors of Hull-House, Chicago's first settlement house. The decision of these two young women to "settle" in Chicago's crowded immigrant district was the result of much soul searching about their place in society. It was also a product of a particular historical moment in which immigration, industrialization, and the Progressive reform impulse came together in Chicago.

Between 1880 and 1900, nine million immigrants from the rural villages and small towns of Southern and Eastern Europe journeyed to the United States. Many settled in cities like Chicago, where the new industrial economy needed cheap, unskilled labor. Known as the "new immigrants" to distinguish them from their Northern and Western European predecessors, these newcomers brought social and religious customs that seemed foreign and threatening to many Americans.

At the same time, the 1890s witnessed the birth of the Progressive Era in which scholars, ministers, and journalists began to question the philosophies of individualism and laissez-faire capitalism that had characterized the post-Civil War period. Leaders of the Progressive movement began to recognize that poverty and its accompanying social problems were not necessarily due to the moral failure of the poor, but rather were byproducts of industrial capitalism.

Finally, the end of the 19th century saw increased educational opportunities for upper middle-class women. Jane Addams and her contemporaries were the first generation of women to go to college. Many of these women, whose horizons had been broadened by study and the independent living of a college dormitory, longed for a role in the public sphere, outside the home. For them, social settlements like Hull-House offered just the socially meaningful opportunity they sought.

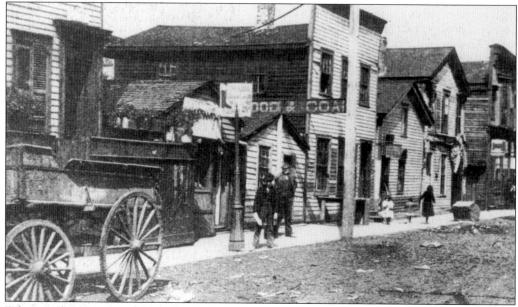

When real estate developer Charles J. Hull invested in large tracts of land to the west of Chicago in the early 19th century, he hoped the area would become a prosperous residential community. Instead, by 1889 the Near West Side was a crowded port-of-entry neighborhood for Chicago's new immigrants from Southern and Eastern Europe. (JAMC 198)

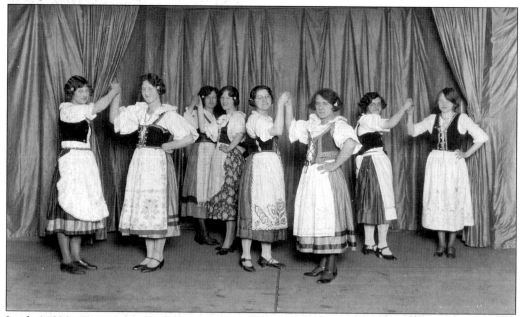

In the 1890s, Jane Addams described the neighborhood's diversity: "Between Halsted Street and the River live about ten thousand Italians—Neapolitans, Sicilians, Calabrians...To the south on Twelfth Street are many Germans and the side streets are given over almost entirely to Polish and Russian Jews. Still farther south these Jewish colonies merge into a huge Bohemian colony...To the North West are Canadian-French, clannish in spite of their long residence in America, and to the north are Irish and first generation Americans." (BHNC)

Each of these ethnic groups brought the food, language, dress, music, and festivals of their native lands to the Near West Side. By the end of the 19th century, the neighborhood was a patchwork of vibrant ethnic communities, many of which founded their own social and religious institutions. Holy Family Church, pictured here in 2004, was founded in 1857 as the first Jesuit parish in Chicago. When it was dedicated in 1860, it was said to be the third largest house of worship in the country. By the turn of the century, the congregation was made up primarily of Italian immigrants.

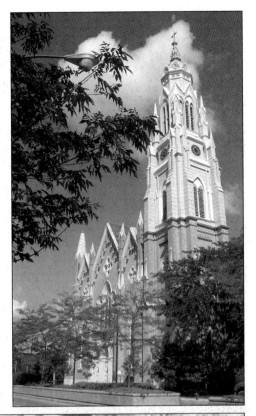

To the south of Hull-House lived a large Eastern European Jewish community. The Maxwell Street market remained a bustling Jewish market until well into the 20th century. (OTSC)

The Near West Side was also home to a large community of Greek immigrants. So many Greeks settled in the area bounded by Harrison, Halsted, and the diagonal Blue Island Street, that the community became known as the Delta, after the triangular shaped Greek letter. Here a Greek grocer sells live lambs along Halsted Street. (JAMC 3157)

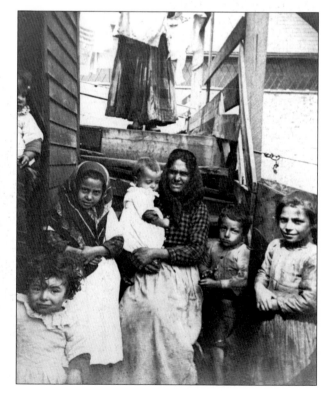

Although the Near West Side was home to a vibrant community life, the physical conditions of the neighborhood were deplorable. By the 1890s, the 19th Ward of Chicago was the most densely populated ward in the city. The majority of families lived in small, dark, and crowded tenement houses. (JAMC 3117)

Many of the new immigrants of the Near West Side worked in the local men's garment industry, as manual laborers, or in the street trades as peddlers, or even prostitutes. For the most part, this work was hard, long, and extremely low paying. Often, all members of a family, including children, needed to earn a paycheck for the family to survive. (JAMC 914)

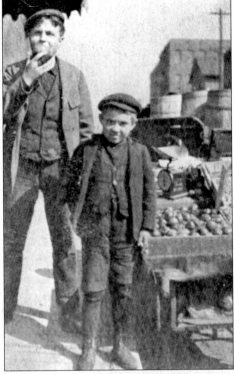

Largely neglected by the city government at the turn of the 20th century, the streets of the 19th Ward remained unpaved and the garbage went uncollected. Hundreds of homes were unconnected to the city sewer system and the carcasses of workhorses that died on neighborhood streets would be left for days before being picked up. (JAMC 3110)

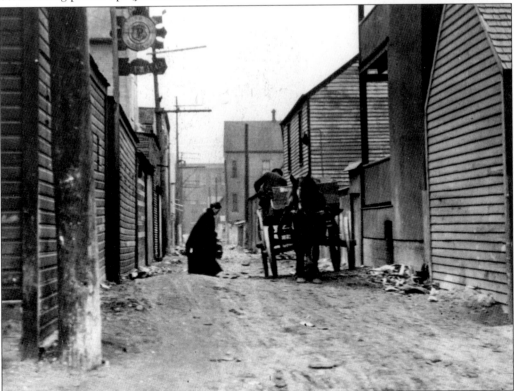

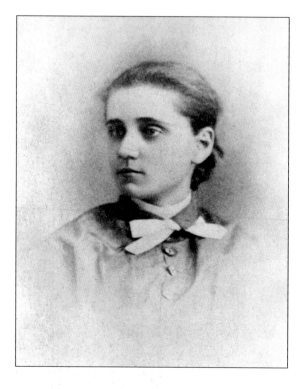

It was into this bustling and teeming environment that Jane Addams (top) and Ellen Gates Starr (below) decided to bring their experiment of "settling." Addams and Starr met in 1877 while students at Rockford Female Seminary in Rockford, Illinois where they were among the first generation of women to attend college. (JAMC 1447)

Addams and Starr sought to find roles for themselves outside of the traditional avenues of missionary, teacher, and maiden aunt open to unmarried Victorian women. Both women also lived, for a time, in large American cities and were increasingly dismayed by the living conditions of the urban poor. (JAMC 3567)

For nearly a decade after graduating from Rockford Seminary, Addams in particular struggled to find her calling. Her father, John Addams, a wealthy businessman and Illinois State Senator had impressed upon his daughter the responsibility of the elite classes to the community as a whole. Yet, for a young woman who rejected missionary work and felt unsatisfied with traditional philanthropy, there seemed to be no outlet for this impulse. (JAMC 609)

In 1887, Addams and Starr traveled to Europe, where Jane Addams visited London's Toynbee Hall, the pioneering university settlement founded by Canon Samuel Barnett. Addams wrote to her sister Alice of her impressions of the settlement: "It is a community for University men who live there, have their recreation and clubs and society all among the poor people…. It is so free of 'professional doing good' so unaffectedly sincere and so productive of good results in its classes and libraries that it seems perfectly ideal." (JAMC 3361)

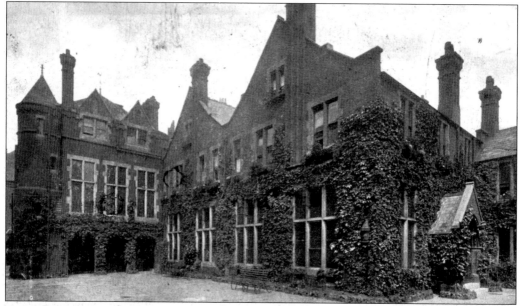

Toynbee Hall, pictured here, provided Addams and Starr with a model for their plans to "do some work together." In 1889, the friends rented an apartment in Chicago and looked for support for their settlement house. Starr and Addams soon won the confidence of a number of local clergy, philanthropists, and members of the Chicago Woman's Club. One Woman's Club member was Helen Culver, a wealthy, unmarried businesswoman who had inherited the estate of her cousin, Charles Hull. Culver agreed to rent Addams and Starr her cousin's slightly dilapidated mansion on Halsted Street in the 19th Ward. (JAMC 848)

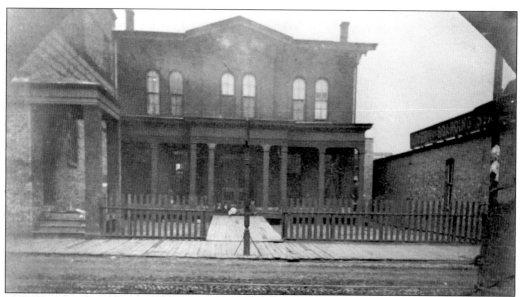

Hull's house, a large brick building with a broad veranda on three sides, was built in the 1850s. The house now stood in the midst of a working-class immigrant neighborhood. Upon first visiting the house, Jane Addams wrote to her sister that the people living in the Near West Side were "more crowded than I thought people lived in America." (JAMC 132)

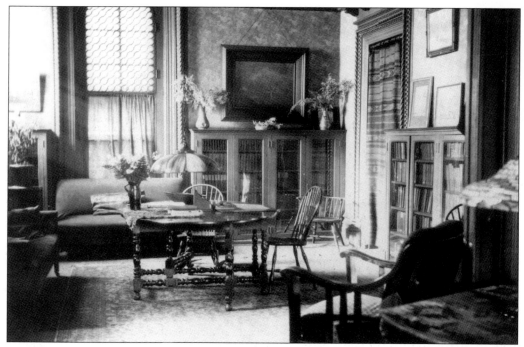

Upon moving in to Hull-House, Addams and Starr set out to make it their home. "We furnished the house as we would have furnished it were it in another part of the city, with the photographs and other impedimenta we had collected in Europe and with a few bits of family mahogany... Probably no young matron ever placed her own things in her own house with more pleasure than that which we first furnished Hull-House," recalled Addams in her autobiography. (JAMC 207)

At first, Addams and Starr had no formal programs. They simply opened the house and invited their neighbors in, hoping that their home would be a comfortable refuge for them. (JAMC 2973)

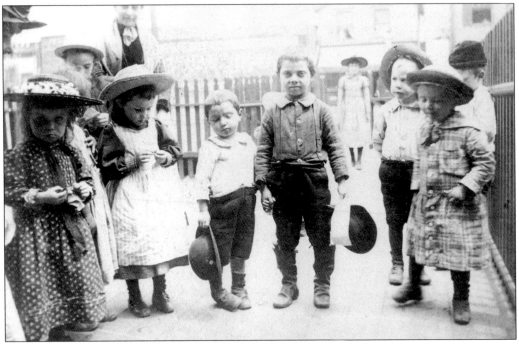

Children were among the first curious visitors. Addams, Starr, and a group of volunteers soon organized the children into informal clubs, holding a kindergarten in the drawing room. (JAMC 1270)

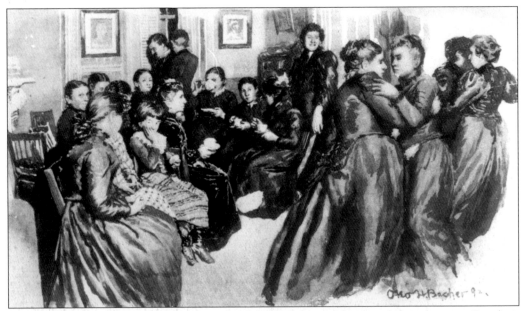

Addams and Starr also tried to attract their wary adult neighbors to the settlement. On their first New Years Day at Hull-House, Addams and Starr organized an "Old Settler's Party" for their often-lonely elderly neighbors. Soon after, they began holding "ethnic nights" featuring music and dancing from different corners of Europe. This illustration of German Night appeared in *Scribners*, 1892. (JAMC 2490)

By 1897, an inner circle of capable and committed social reformers had joined the settlement house as residents—volunteer staff members—including Alice Hamilton, Florence Kelley, and Julia Lathrop, pictured here. The residents, most of whom were young, educated men and women, helped significantly to expand the activities of Hull-House. (JAMC 476)

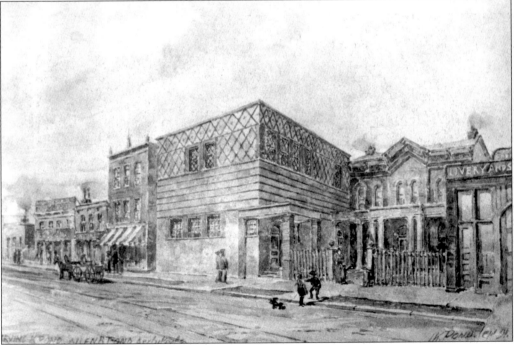

As the programs expanded so did the settlement house itself. The first addition was the Butler Gallery, pictured here, in 1890. It housed an art gallery, a branch of the public library, and space for classes. (JAMC 159)

Subsequent additions to Hull-House were designed by the architectural firm of Pond & Pond. Irving and Allen Pond were supporters of the settlement movement and prominent members of the Arts and Crafts movement in Chicago. By 1907, the settlement had grown to be a 13-building complex encompassing an entire city block. (JAMC 156)

Two

TO NOURISH
THE SPIRIT

In formalizing the Hull-House program, Addams and Starr modeled their efforts on their own college experiences and on the example set by Toynbee Hall. In the Hull-House neighborhood, they saw little evidence of what they considered culture: fine art, classical music, access to the canon of Western literature, or debate over philosophical issues. Believing that nourishing the spirit and exercising the mind were essential to a rich and full life, they eagerly shared their knowledge of culture and the arts with their neighbors. Sunday afternoon concert music, artwork for exhibitions, and books for reading parties were carefully chosen according to residents' standards of quality in order to educate and elevate the tastes of their neighbors. College and university extension classes focused on traditional academic subjects such as literature, mathematics, and history. While concerts and art exhibits were popular, the settlement's educational fare possessed a persistent but limited appeal.

As Hull-House residents came to know their neighbors, programming initiatives changed. The settlement experimented with classes that would teach skills useful to working and home life and neighbors responded with enthusiasm. Adults valued English classes for their utility in getting a job and navigating the city, working mothers confidently left their children in the Hull-House nursery, and young people attended vocational training in hopes of escaping a future of manual labor. Convinced that education was most effective when dispensed in a social atmosphere, settlement residents designed activities that combined learning with pleasure.

Hull-House residents also learned to celebrate immigrant culture, not just as a means to draw in neighbors, but as a valuable addition to American life. Activities and classes began to include folk dancing, ethnic theater, and immigrant handicrafts. By showcasing ethnic art forms, Hull-House hoped to foster understanding among ethnic groups and appreciation by the wider public. While reading parties of Shakespeare and lectures on scientific topics continued, the settlement program broadened to respond more directly to the specific needs of the neighborhood. In the process, Hull-House created an innovative and exciting cultural environment that tested new progressive theories of education.

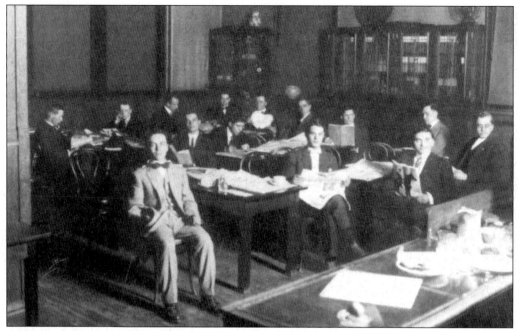

Addams and Starr cultivated an environment in which education and ideas could flourish. Starr organized reading parties, resident Julia Lathrop led discussions of philosophy in the Plato Club, and the Working People's Social Science Club hotly debated current events. In the 1890s, College Extension classes included art history, English literature, Latin, mathematics, languages, and even "Elementary Lessons in Electricity and Magnetism" taught by future president of General Electric, Gerard Swope. A public reading room provided access to literary works as well as ethnic newspapers. (JAMC 3021)

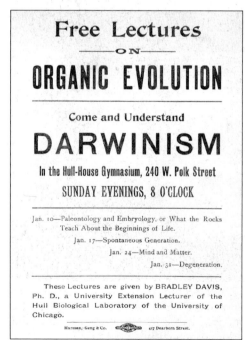

Free Lectures
—— ON ——
ORGANIC EVOLUTION

Come and Understand
DARWINISM

In the Hull-House Gymnasium, 240 W. Polk Street
SUNDAY EVENINGS, 8 O'CLOCK

Jan. 10—Paleontology and Embryology, or What the Rocks Teach About the Beginnings of Life.

Jan. 17—Spontaneous Generation.

Jan. 24—Mind and Matter.

Jan. 31—Degeneration.

These Lectures are given by BRADLEY DAVIS, Ph. D., a University Extension Lecturer of the Hull Biological Laboratory of the University of Chicago.

Harman, Geng & Co. 417 Dearborn Street.

An extensive lecture program included topics of local economic, scientific, and political interest. Addams noted that professors who dropped into "dull terminology" often lost their audiences. Yet, a 12-week course on "Organic Evolution" proved tremendously popular due to the stimulating talk given by a researcher who had not yet achieved professorial status. (Kirkland)

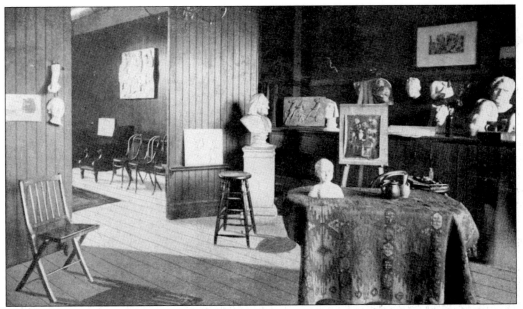

The Butler Gallery, built in 1891, staged exhibitions of artwork loaned by wealthy Chicago citizens during hours in which working people could attend. Ellen Gates Starr chose artwork that she believed best provided an ennobling influence. Thousands attended the popular exhibits. The second floor of the Butler Gallery also contained an art studio. Beginning in the 1890s, artist Enella Benedict and her assistants taught classes in drawing, painting, modeling, and lithography. On Sundays, a live model was available. (Residents of Hull-House)

In 1894, Ellen Gates Starr helped found the Chicago Public School Art Society to provide art to the public schools. Urban children with no exposure to nature, Starr argued, especially needed the solace of good artwork and its spur to the imagination. Starr hoped that exposure to beauty and heroism through art would stir the ambitions and emotions of young children. (ART)

VIOLIN RECITAL
GIVEN BY
JOSEPH H. CHAPEK,
Concert Violinist and Musical Director.
ASSISTED BY
Mrs. Augusta Haenel-Chapek,
Contralto and Piano
AND THE VIOLIN DEPARTMENT OF
J. H. CHAPEK'S MUSICAL INSTITUTE.

Sunday, June 2d, '95, at 4:30 P. M.

AT THE

Hull House Gymnasium,
Cor. Halsted and Polk Sts.

PROGRAMME.

1. "From My Home", duet for violin and piano, No. 2 G minor ... *B. Smetana*
 Mr. J. H. Chapek and Mrs. Chapek.
2. Violin Solo, "Oberon" *Weber-Daube*
 George Apfelbach.
3. "Gigue" Violin Solo in Unison *Leonard*
 Advanced Violin Pupils.
4. Contralto Solo, "What the Chimney Sang" *Gertrude Griswold*
 Mrs. Augusta Haenel-Chapek.
5. Scene Champetre, for 4 Violins *Papini*
 Messrs. Chapek, Steffeck, Prindeville and Weisskopf.
6. Petite Gavotte, for Violin and Piano *Daube*
 Adolph Kausal and Laura Nichols.
7. Violin Solo, Ballade et Polonaise *Vieuxtemps*
 Mr. J. H. Chapek.
8. Two Songs, a) Faith and Courage *Bendl*
 b) Class Song *Chapek*
 The Singing Class, accompanied by the Violin Pupils.
 String Orchestra and Piano.

A. E. BECKER & CO., 882 W. 12TH STREET.

Hull-House also employed music to raise the cultural level of their neighbors. Free concerts by visiting artists were given on Sunday afternoons with music carefully chosen both to educate and entertain. By 1895, audiences of up to 400 people attended and the *Hull-House Bulletin* was pleased to note that the audience had begun to be more respectful and attentive. (HHA)

In 1893, Eleanor Smith and Amalie Hannig founded the Hull-House Music School, one of the first community-based music schools in the country. Among the most popular activities at the settlement, the program included a variety of lessons and performance venues. The cost of instruction was typically about one-third the cost of private training. Children who could not afford to pay often received free lessons or sheet music. Here, Smith meets with a class of young children. (JAMC 417)

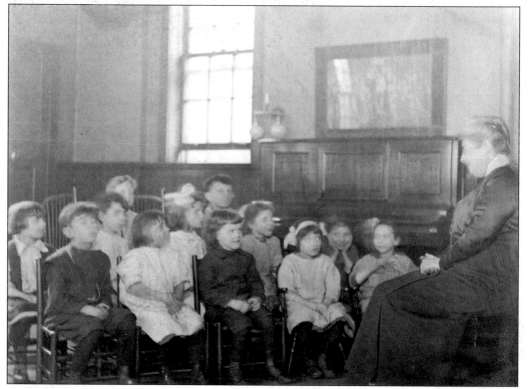

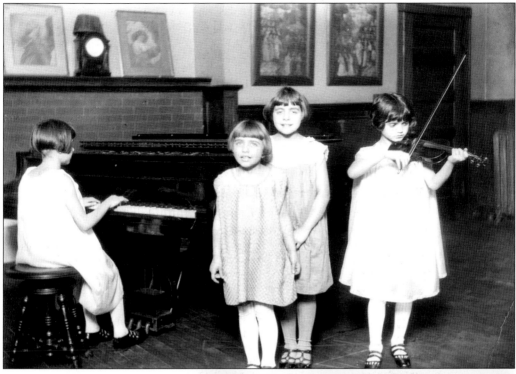

Smith and Hannig stressed strong technical skill, high standards of excellence, and training for professional careers. All Music School students were encouraged to gain composition and performance experience, no matter what their age or level of play. (JAMC 259)

From its first year, the Hull-House Music School held annual Christmas concerts on the Sunday before the holiday. In later years, the concert was enhanced by a series of tableaux. Hull-House was proud that children of all faiths and nationalities took part, although the program undoubtedly caused friction within the families of the Jewish participants from the neighborhood. (JAMC 1018)

Believing that bodily health enhanced mental health, resident Rose Marie Gyles supervised exercise and team sports in the newly built Hull-House gymnasium. At a time when women were discouraged from participating in team sports, Hull-House fielded one of the first women's basketball teams in the city. (JAMC 1254)

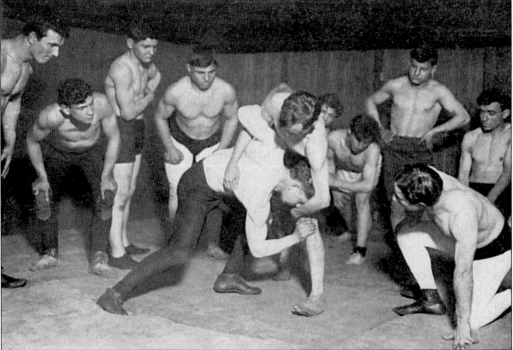

Greek immigrants flocked to the Hull-House gymnasium for traditional wrestling classes. Although one student won the citywide championship, Hull-House residents hoped young athletes would remain amateurs and not enter the sordid world of professional sports with its connections to gambling and pugilism. (JAMC 942)

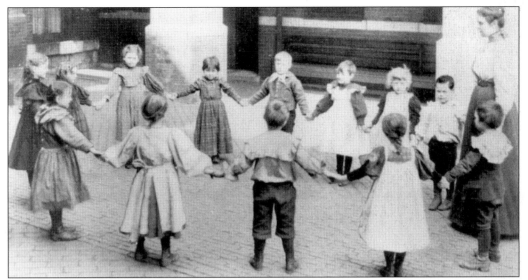

From the beginning, the needs of the neighborhood increasingly pushed Hull-House towards activities with more direct relevance and usefulness to the life of the neighborhood. A kindergarten, prompted by the needs of working women, provided a safe place for children while their mothers were at work. Jenny Dow, a vivacious and cheerful young kindergarten teacher from the North Side of Chicago, had 24 children enrolled within the first three weeks. A Day Nursery served younger children. (JAMC 377)

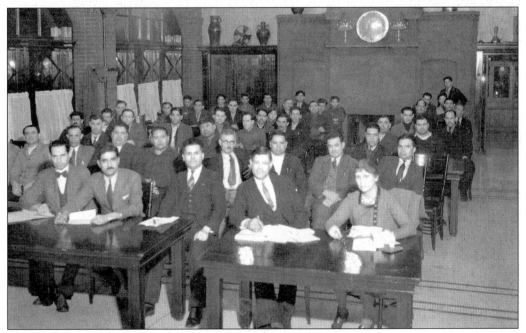

Settlement residents believed that democracy depended on active participation. To encourage their immigrant neighbors to become citizens and to exercise their rights knowledgeably, Hull-House taught English and held citizenship and naturalization classes. Many Hull-House residents also worked to extend the vote to women. Here, resident Jessie Binford, seated on the right, conducts a citizenship class. (Kirkland)

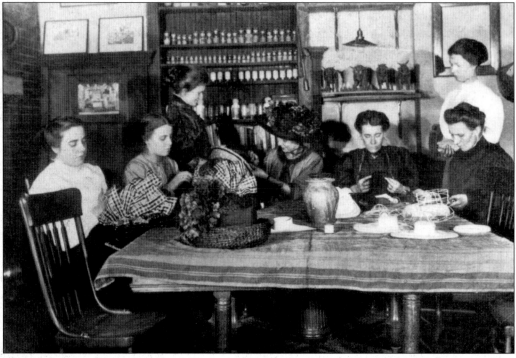

Classes that taught marketable skills were popular. Sewing and hat-making lessons provided social interaction as well as a finished product to take home. Women made use of the classes to sew for their families but also as training that could shorten apprenticeship time towards becoming a milliner or dressmaker. (JAMC 255)

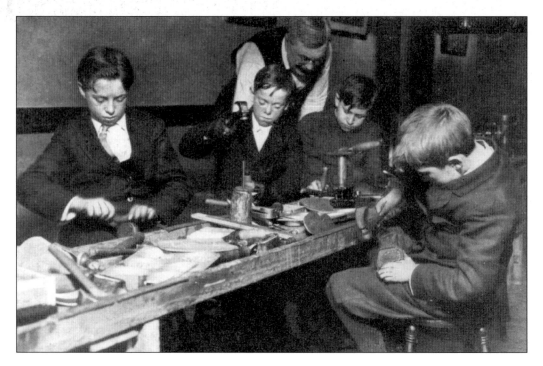

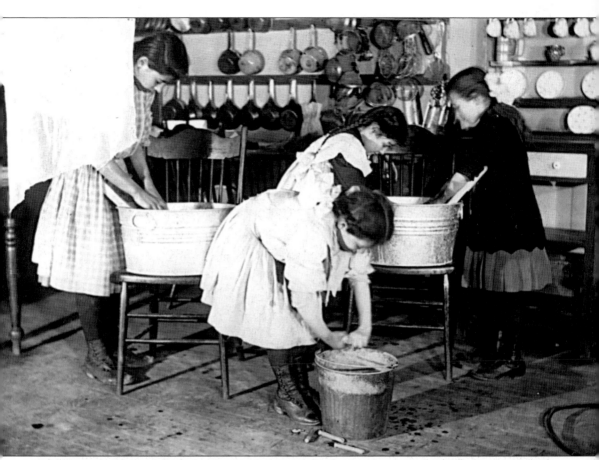

Hull-House residents believed that families needed new techniques to deal with life in the modern city. As future homemakers, the health and morals of neighborhood families were dependent on young women and girls. Many settlement classes were designed to train them in housekeeping skills. (JAMC 641)

Opposite: Taught by working men rather than professional teachers, manual training classes in carpentry, electricity, tinsmithing, brass molding, typesetting, typewriting, cobbling, photography, and management of telephone switchboards exposed young boys to options in choosing a trade. (JAMC 139)

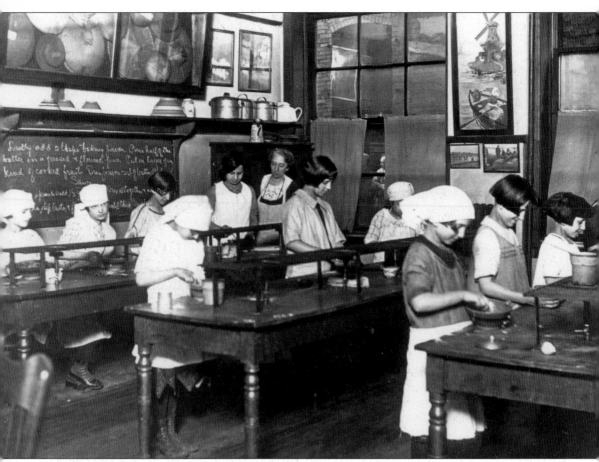

Cooking classes educated young girls and women in the selection, preparation, and serving of food. Instructors designed lessons to teach the latest in modern sanitary methods, reflect current nutritional theories, and help homemakers to economize healthfully. (JAMC 140)

Opposite: In 1897, businessmen, academics, settlement residents, practicing crafts people, and architects founded the Chicago Arts and Crafts Society at Hull-House to promote hand craftsmanship, simple design, and the restoration of dignity to workers whose skills and status were eroding under industrialization. By 1905, almost one-third of the Hull-House residents practiced some handicraft in workshops for painting, pottery, metal work, printmaking, and woodworking. (JAMC 254)

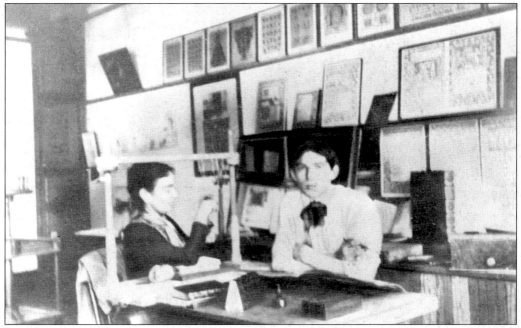

Arts programming reflected the settlement residents' growing understanding of the impact of industrialization on their neighbors' lives. Influenced by the Arts and Crafts movement, Starr criticized factory work for robbing people of their creative powers and deadening their spirits. Convinced of the individual and social value of the act of creation, in 1896 she studied bookbinding and set up a small bindery at Hull-House. This photograph shows Starr in her Hull-House bookbindery with one of her most accomplished pupils, Peter Verburg. (JAMC 2084)

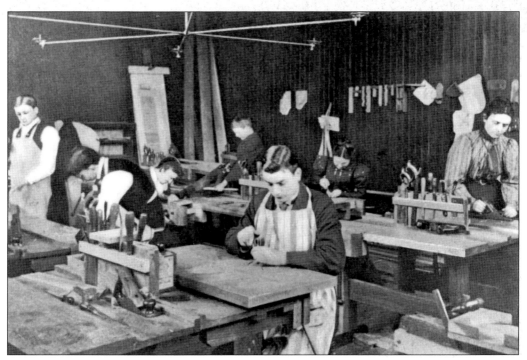

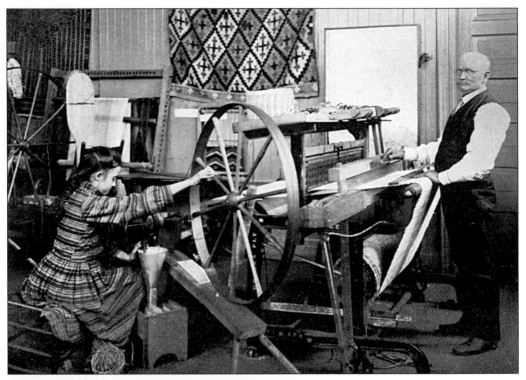

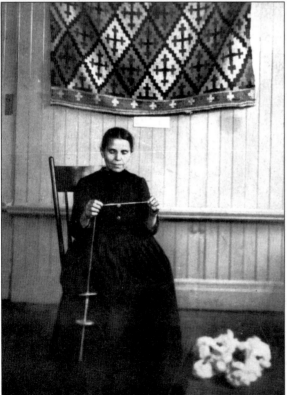

Within the Labor Museum, established in 1900, neighborhood immigrants demonstrated historic crafts for visitors. The museum hoped to inspire appreciation of immigrant skills and help young industrial workers understand their important role in the history of craft. Manual training shops connected with the museum exposed young workers to creativity in craftwork. (JAMC 249)

Here, an Italian woman demonstrates spinning with a primitive stick spindle. Aware of the temptation to romanticize the craft activities of the past, Addams recounted finding a young Greek boy staring wistfully at a spinning demonstration in the Labor Museum. "I suppose this reminds you of your mother," she said. "Yes," he answered, "I don't like to look at a stick spindle; she always beat me with it." (JAMC 540)

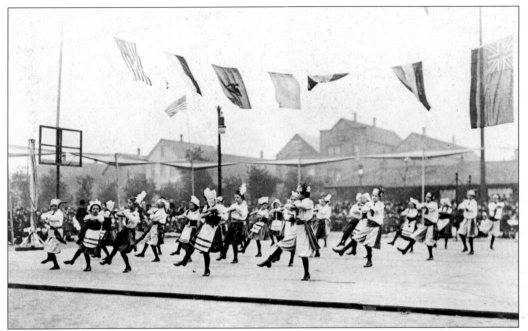

Folk dancing played a special role at Hull-House because of the neighborhood's large immigrant population. Mary Wood Hinman, a pioneer in the study and teaching of folk dance, taught at the settlement house from 1898 to 1909. Hinman believed in teaching immigrant children the dances of their parents, thereby establishing an important inter-generational connection. Dancers often wore ethnic costumes from their parents' homelands. (JAMC 291)

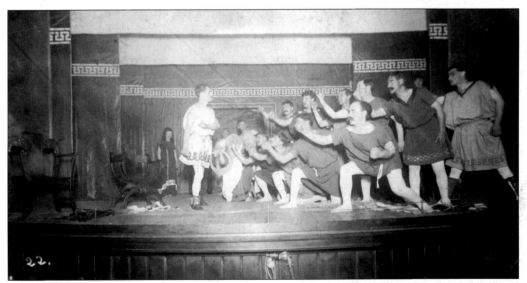

Hull-House became a showcase for ethnic drama. In 1899, neighborhood residents presented *The Return of Odysseus* in ancient Greek in the newly built Hull-House Auditorium. In 1903, director Mabel Hay Barrows was invited back to stage *The Ajax of Sophocles*. The *Hull-House Yearbook* reported on the delight of the Greek community, who felt Chicagoans ignored their history and culture. Russian, Yiddish, Lithuanian, Hungarian, Italian, Bohemian, and later Latvian and Mexican plays were performed, often in native language. (JAMC 4288)

The Hull-House Players, directed by resident Laura Dainty Pelham, were drawn from the surrounding tenements. A nationally and internationally respected ensemble company, the Hull-House Players performed the Chicago premiers of several plays by Galsworthy, Ibsen, and Shaw. Maurice Brown, founder of the Little Theater in Chicago, praised Hull-House productions and declared in his autobiography, "Mrs. Pelham, not I, was the true founder of the 'American Little Theater Movement.'" (JAMC 531)

A frequent visitor, educational philosopher John Dewey often exchanged ideas on educational theory with Jane Addams. Dewey saw Hull-House as the embodiment of his belief in learning by doing and as a model for public schools. His daughter later wrote, "Dewey's faith in democracy as a guiding force in education took on both a sharper and a deeper meaning because of Hull-House and Jane Addams." (Dewey)

The
SCHOOL
and
SOCIETY
BEING THREE LECTURES
by

JOHN DEWEY
PROFESSOR OF PEDAGOGY IN THE UNIVERSITY OF CHICAGO

SUPPLEMENTED BY
A STATEMENT OF THE UNIVERSITY ELEMENTARY SCHOOL

1900
CHICAGO
THE UNIVERSITY OF CHICAGO PRESS
NEW YORK
Mc CLURE, PHILLIPS & COMPANY

Three

HUMANIZING THE INDUSTRIAL CITY

Settlement workers realized that to make a real difference in the life of their neighborhood, they needed to move beyond cultural activities to address more fundamental life issues. Dismal and dilapidated housing, rampant disease, abysmally low wages, and backbreaking labor drained the spirits and injured the bodies of neighborhood residents. Traditional explanations for poverty placed the blame on the individual and prescribed hard work, prayer, or frugality as the cure. New immigrants, especially, were accused of being inherently lazy and unfit for American life. Convinced that accurate information was needed to understand the problems of their neighborhood, settlement workers set out to investigate economic, physical, and social conditions on the Near West Side.

Their studies found environment, not individual character, to blame for the many problems facing their neighborhood. Housing, sanitation, social and cultural facilities, and public health initiatives had not kept pace with the explosion of urban population as the city rapidly industrialized. Civic responsibility had deteriorated as extremes of wealth and poverty divided the metropolis. Hull-House residents argued that their immigrant neighbors could enrich the cultural and economic life of Chicago if given the chance. Humanizing the industrial city, they argued, demanded cooperative action to create an environment in which opportunity flourished for all.

Women, especially, had an important role to play in shaping the urban environment. For generations, they had dealt with issues of proper sanitation, a living wage, and accessible health care for their own families. As formerly private issues expanded in scale to become public, this valuable experience could bring new insights and approaches to reform agendas. At Hull-House, women residents led many of the settlement house's most effective reform initiatives.

Through their studies of neighborhood conditions and their active use of this information to experiment with solutions, Hull-House residents contributed to a wide range of progressive reform campaigns, presenting their findings on the city, state, and national stage. Their efforts influenced ideas about poverty, public health, education, immigration, and labor and helped establish new expectations for governmental responsibility.

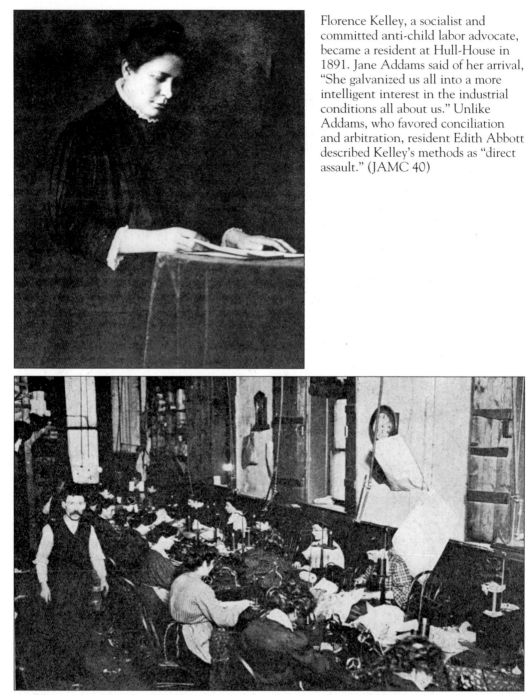

Florence Kelley, a socialist and committed anti-child labor advocate, became a resident at Hull-House in 1891. Jane Addams said of her arrival, "She galvanized us all into a more intelligent interest in the industrial conditions all about us." Unlike Addams, who favored conciliation and arbitration, resident Edith Abbott described Kelley's methods as "direct assault." (JAMC 40)

As a special agent for the Illinois Bureau of Labor Statistics, Kelley visited homes and workplaces to document conditions of sweated labor in the garment industry, one of the largest employers in the Hull-House neighborhood. In tenement sweatshops, women and children sewed for long hours in dark, unventilated basements and attics. By subdividing work until tasks required virtually no skills, garment manufacturers were able to offer wages below that of any other city trade, making it impossible to earn a living wage. (Tobenkin)

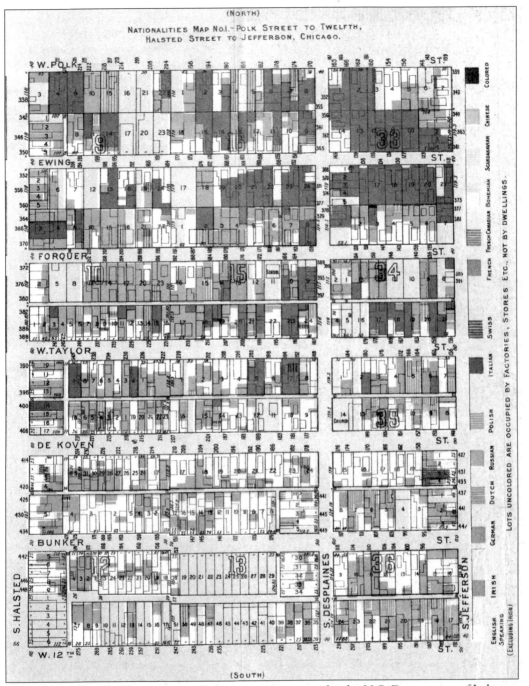

Kelley's work for the Illinois Bureau led to an appointment by the U.S. Department of Labor to conduct the Chicago portion of a study of *The Slums of Great Cities*. The information she gathered later formed the basis of wage and nationality maps published in Hull-House's pioneering sociological study of neighborhood conditions, *Hull-House Maps and Papers*. The color-coded maps graphically showed the ethnic diversity and low wages prevailing in the area east of the settlement. (Residents of Hull-House)

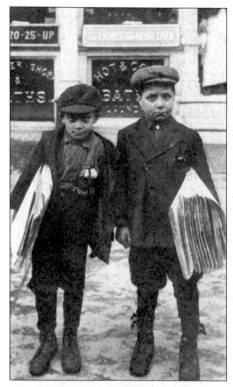

In *Hull-House Maps and Papers*, Florence Kelley and resident Alzina Stevens reported that newsboys rose in the dark each day to obtain the earliest edition of the paper and blacked boots and pitched pennies in-between sales. "They are ill-fed, ill-housed, ill-clothed, illiterate, and wholly untrained and unfitted for any occupation." With other Chicago settlements, Hull-House sponsored an investigation of a thousand 'newsies' and recommended a local regulating ordinance. (*Child in the City*)

In neighborhood factories, children risked throat disease during frame gilding, lung disease in boiler-plate, cutlery, and metal-stamping works, nicotine poisoning in tobacco factories, and in neighborhood bakeries "children slowly roast before the ovens." Despite the efforts of reformers nationwide however, national legislation curtailing child labor did not come until passage of the Fair Labor Standards Act in 1938. (JAMC 319)

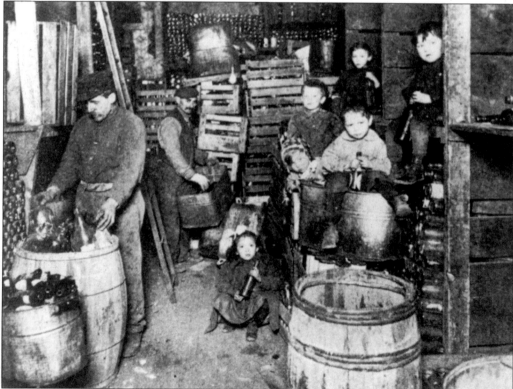

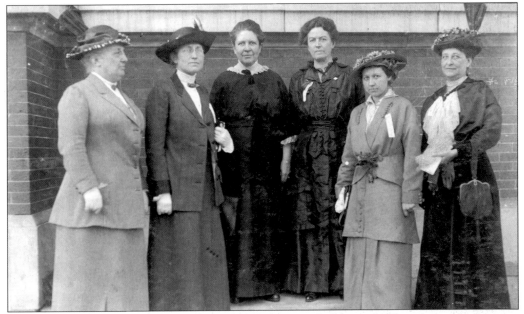

Kelley led a campaign that culminated in passage of the state's first factory inspection legislation in 1893. The statute abolished child labor for children less than 14 years of age and banned tenement garment sweatshops. Liberal Governor John Peter Altgeld appointed Kelley as the state's first factory inspector. For the next three years, Kelley worked with resident Alzina Stevens and 11 deputies to enforce the provisions of the act. Kelley is pictured here (third from left) with factory inspectors from several states. (Library of Congress)

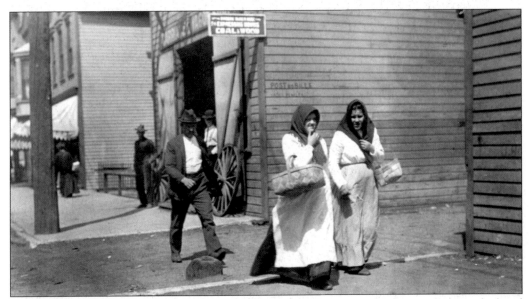

An eight-hour day clause for women and children in the state factory law was later declared unconstitutional. Settlement residents advocated protective legislation for women, most of whom worked at unskilled labor. They were concerned with the plight of working women, who were expected to put in long hours at factories or in piece-work but were still responsible for childcare, cleaning, and shopping for their families. (JAMC 297)

You are hereby cordially invited to
attend a

Mass Meeting

..AT THE..

Hull House,

240 W. Polk Street, Corner
Halsted St.

..ON..

Sunday, September 29th,
at 3 P. M. sharp.

For the purpose of organising a
Ladies' Branch of the
Tailoring Trade
in order to better your conditions.

Good Ladies and Men speakers will address you.

Bring your Friends with you.

By Order of the Committee of the

**United Garment Workers
of America.**

A. E. BECKER & CO., 263 W. 18TH STREET.

Hull-House residents believed unions were an essential influence in obtaining better working conditions. Women's unions needed alternatives to the saloon as a place to hold meetings and in the 1890s, Mary Kenney, a neighborhood worker, brought her women's bookbinding union to meet at Hull-House. Women shirt makers and women cloak makers organized at Hull-House, and the Dorcas Federal Labor Union, composed of representatives from unions with women members, met once a month in the Hull-House drawing room. (HHA)

Kenney also helped found the Hull-House Jane Club, a cooperative boarding house for working women. By establishing their own boarding house, 'Janes' could support each other during strikes. Hull-House provided the first month's rent and furniture for two apartments on Ewing Street. The Jane Club later had its own brick building that comfortably accommodated 30 women. Self-governed and regulated, the Jane Club afforded companionship but also a measure of autonomy. (JAMC 1492)

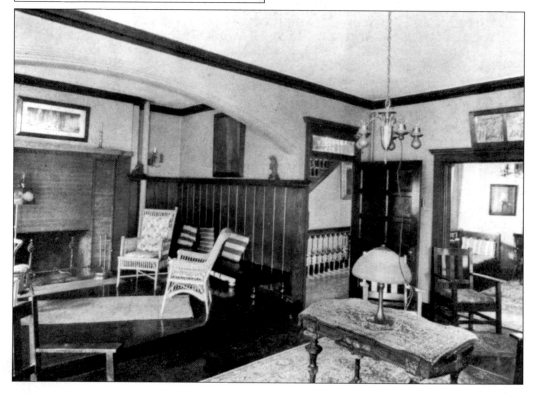

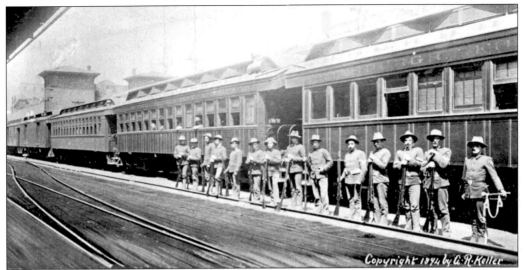

While the settlement supported unions, Addams abhorred class conflict and always advocated arbitration over strike actions. During the Pullman Palace Car strike of 1894, she served as a member of the Citizens' Arbitration Committee, which tried to bring both sides to the bargaining table. Pullman refused arbitration and a violent nationwide strike ensued. Federal troops were called into Chicago and the strike was eventually broken. (Swinton)

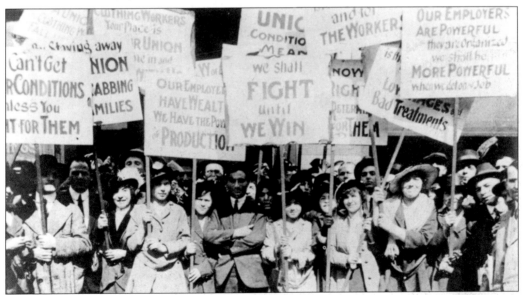

Co-founder Ellen Gates Starr had no qualms about direct involvement in labor disputes. In 1910 and 1915, she actively supported striking garment workers. Resident Alice Hamilton picketed only at times of day when arrests were unlikely but Starr didn't shy from jumping into the fray. Arrested for disorderly conduct while picketing with striking Henrici Restaurant waitresses in 1914, she was defended by Harold Ickes, then a young Chicago lawyer. The court erupted into laughter when a policeman accused the frail-appearing Starr of trying to "frighten him from the discharge of his duty." Despite her appearance, however, Starr was a vigorous and fearless defender of labor and occasionally acted in opposition to other less-militant Hull-House residents. (Amalgamated Clothing Workers of America–UIC)

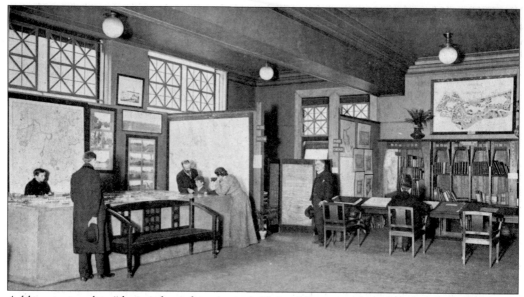

Addams wrote that "during those first years on Halsted Street nothing was more painfully clear than the fact that pliable human nature is relentlessly pressed upon by its physical environment." In 1900, Addams and Anita McCormick Blaine, the daughter of reaper magnate Cyrus McCormick, helped establish the City Homes Association. Designed as a clearinghouse for reform data, the Municipal Museum established by the City Homes Association, collected materials relating to housing, playgrounds, municipal art, and urban transportation. (Zueblin)

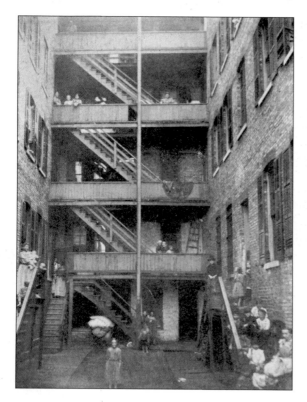

The City Homes Association sponsored an investigation of housing that aided in the passage of a tenement house ordinance in 1902. Hull-House residents also contributed studies of neighborhood housing to the *American Journal of Sociology*. As trusted and committed residents of the Hull-House neighborhood, they supplemented first-hand observations with information gained through personal contacts. (JAMC 314)

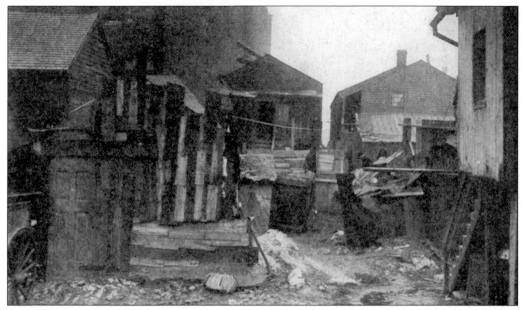

In *Hull-House Maps and Papers*, resident Agnes Holbrook described the Hull-House neighborhood, "Little idea can be given of the filthy and rotten tenements, the dingy courts and tumble-down sheds, the foul stables and dilapidated outhouses, the broken sewer-pipes, the piles of garbage fairly alive with diseased odors, and of the numbers of children filling every nook, working and playing in every room, eating and sleeping in every window-sill, pouring in and out of every door, and seeming literally to pave every scrap of 'yard.'" (JAMC 5556)

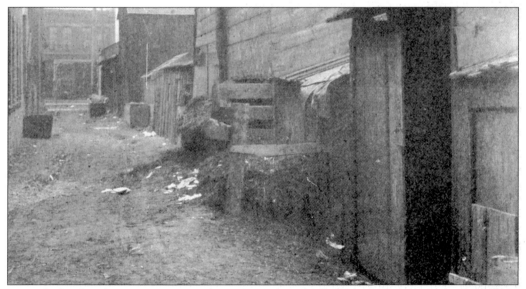

Instead of toilets, homes unconnected to city sewers relied on wooden privies constructed over brick or stone vaults. Privies needed to be manually emptied. Conscientious landlords hired scavenger services for this unpleasant task; others left the contents to fester. As rains seeped into privy vaults, they overflowed into already foul alleys and backyards. Families in rear tenements adjacent to the privies kept their windows shut in hot weather to lessen the unbearable stench. (Hunter)

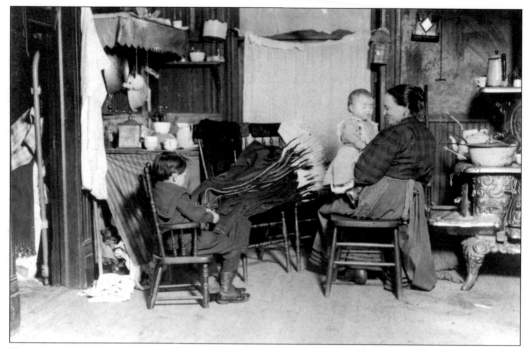

Housing studies revealed conditions that made homelife difficult. Small flats of two to four rooms housed large families and kitchens often doubled as sleeping space. Homes below street level resulted in cold and damp basement flats. Coal for heating and cooking needed to be bought in small quantities and was sometimes stored within the flat itself. Hull-House sponsored housekeeping classes but also criticized landlords for allowing these conditions to exist. (JAMC 1022)

Hull-House Kitchen

240 West Polk Street
Near Halsted

Has been carefully fitted up with double-jacket steam kettles and Aladdin ovens. Customers are invited to visit the kitchen.

Save Fire and Labor this Hot Weather. Buy Your
Meals Ready Cooked—Cheaper than
Cooking at Home

PRICE LIST

SOUPS..10 CENTS PER QUART

Tomato Soup,	Cream of Peas
Vegetable Soup,	Cream of Asparagus
Pea Soup,	Cream of Corn
Cream of Celery	

Beef Broth—for Invalids,	18 cents per quart	
Ham,	40 " " pound	
Roast Beef .	30 " " "	
Mutton Stew,	10 " " "	
Beef Stew, .	10 " " "	
Corned Beef Hash,	15 " " "	
Steamed Rice, .	10 " " "	
Rice Pudding—in Bowls,	10 " each	

ON FRIDAYS ONLY

| Creamed Cod Fish, | 15 cents per pound |
| Fish Balls, . | 30 " " dozen |

Public Restaurant and Bakery
Open Daily

Meals Served from 6 a. m. to 10 p. m. Sundays, 7 a. m. to 9 p. m.
A 15-Cent Supper Served from 5 to 8 p. m.

Home-Made Bread, Baked in Brick Oven...White Bread...Whole Meal

In 1893, Hull-House opened a Public Kitchen designed to sell nutritious, inexpensive meals for working mothers to take home to their families. Despite its roots in direct observation of neighborhood needs, the kitchen proved a failure. The residents had not taken into account the ethnic taste preferences of the neighborhood and the proprietary feelings women had for this family-oriented task. (HHA)

Neighborhood residents valued tenement social life. Almost exclusively Southern Italian and Sicilian, the ramshackle tenements on the Plymouth Court block of the Near West Side housed 250 children. When one of the tenements was slated for demolition in order to create a center for the Immigrants' Protective League, Hull-House residents discovered that families resisted moving. Despite the buildings' physical condition, families were reluctant to separate from friends and relatives. Eventually, they were forcibly evicted. (Norton)

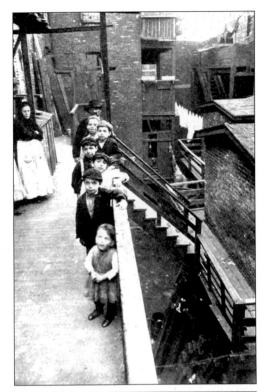

Most reformers believed that filth bred disease. Hull-House determined to clean up both the people and the streets of the neighborhood. In the third-square mile east of Hull-House, only three bathtubs existed. Neighborhood residents readily used various bathing facilities at the settlement, inspiring the residents to persuade a sympathetic supporter to offer rent-free land to the city for the erection of a public bathhouse. (MCL)

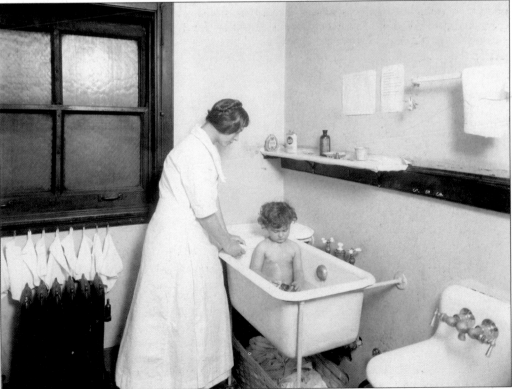

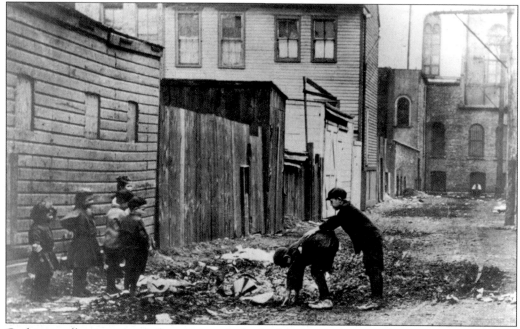

Garbage collection was infrequent and slipshod since garbage collection contracts were politically awarded. An Italian immigrant described the large wooden garbage boxes attached to the pavement, "Inside those boxes the wood was all rotten and juicy. One whole box of garbage was nothing but white worms. After the wagon passed to shovel the garbage out - they weren't careful how it was falling - all the alley was full of white worms. The children, they didn't like those worms! They used to pick up stones and tin cans to throw at them. They couldn't stand it when they squashed them with their bare feet. That garbage was terrible, terrible! I don't know why everybody in Chicago didn't die." (JAMC 296)

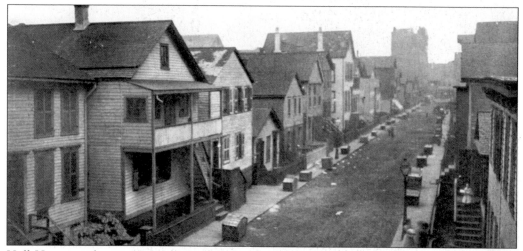

Hull-House residents continually complained to the city—more than 700 times in one summer alone. When their complaints were ignored, Addams submitted a bid for the garbage removal contract. The subsequent publicity forced the mayor to appoint Addams as garbage inspector for the ward. Addams gained national attention as she followed the garbage carts each morning to ensure garbage was thoroughly removed. (Hunter)

As Hull-House sought to clean up the neighborhood and improve services, they came into conflict with Alderman Johnny Powers, the local ward boss. Settlement residents criticized Powers for neglecting physical conditions and for awarding plum jobs to political cronies. In 1896 and 1898, Hull-House unsuccessfully supported candidates to unseat Powers. In "Why the Ward Boss Rules," Addams explained that the settlement could not compete with the politician's ability to hand out jobs, free a child from jail, or contribute to funeral expenses. Although Florence Kelley wished to continue efforts to defeat Powers, Addams chose instead to focus the settlement's energies toward the establishment of a civil service system. (Chicago Historical Society, DN-0072434)

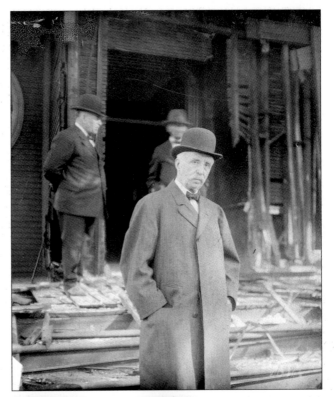

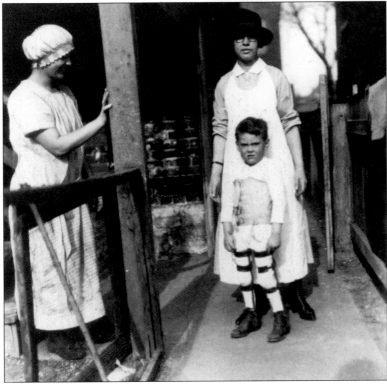

To more directly address health issues, Hull-House became a call station for the Visiting Nurse Association (VNA) and Jane Addams and Louise deKoven Bowen served as directors. Often, families could not afford visits to the doctor and the city's hospitals were largely viewed only as places in which to die. In 1893, the VNA was founded in Chicago to provide home health care and to instruct families in the care of the sick. (JAMC 923)

"At Rest"

ORIGINAL CARTOON BY KING

The Fight for Pure Milk

Milk sold in the Hull-House neighborhood was sometimes diluted with formaldehyde or tinted with bluing to hide spoilage. Bottle-fed babies of working mothers often contracted severe diarrhea that sometimes resulted in death. In response to an 1899 Hull-House study done in cooperation with the Illinois Extension Department, Hull-House installed a 100-gallon tank in the playground to sell pure milk in the summer months. By 1906, the settlement sold 63,000 bottles of milk a year to the surrounding neighborhood. ("The Fight for Pure Milk")

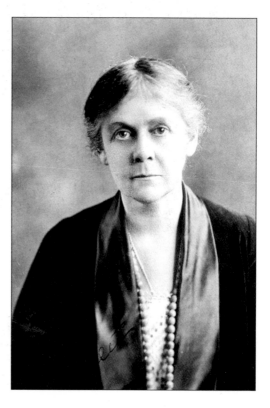

Physician and resident Alice Hamilton found that many neighborhood occupations contributed to the poor health of immigrant workers. As a member of a state and later a federal commission investigating industrial disease, Hamilton identified a wide range of "dangerous trades" in which work processes and materials caused illness or death. A pioneer in industrial toxicology, Hamilton became a recognized authority on a number of diseases including lead poisoning, mercury poisoning, and carbon monoxide poisoning. (JAMC 399)

Reformers worried about moral as well as physical health. They estimated that 20 percent of the young immigrant women traveling alone from Ellis Island never arrived at their destinations. Fear of white slavery—the kidnapping of young women for prostitution—was one of several concerns that sparked the founding of the Immigrants' Protective League. Members met arriving immigrants at Chicago rail stations to help them avoid dishonest cabdrivers, white slavers, and others who might take advantage of their ignorance of city life. Chicago writers exploited the lurid aspects of white slavery in this cover of a 1900 exposé. (*The Traffic in Girls*)

THE DANGERS OF A LARGE CITY

OR

THE SYSTEM OF THE UNDERWORLD

EXPOSING THE WHITE SLAVE TRAFFIC

PRICE ONE DOLLAR

For children, Hull-House fought for compulsory school attendance laws and for supervised after-school play spaces as an alternative to dirty and unsafe streets. They established Chicago's first public playground across from Hull-House in 1894. Surrounded by an iron fence, it offered May Pole dances, organized games, and skating in winter. "And always," reported Dorothea Moore, "it is the place where the crowded children may breathe and run and shout in safety." (JAMC 436)

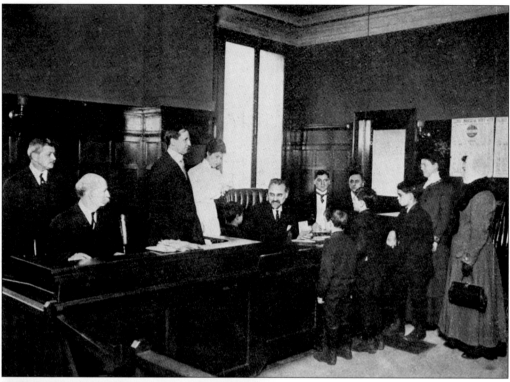

Children arrested by the police were entitled to no special treatment. Through the efforts of Hull-House residents, the Chicago Woman's Clubs and the Chicago Bar Association, an 1899 law established the first Juvenile Court in the nation. The court attempted to help rather than punish children by responding to each child's individual situation. While child offenders avoided the adult court system, they also lost the rights of due process they would normally have been accorded in the criminal courts. (RBC)

The Juvenile Protective Association (JPA) investigated and documented causes of child delinquency. Headquartered in Hull-House, the JPA studied poolrooms, dance halls, theaters, and other locations they deemed dangerous to the morals and health of youth. (JAMC 1099)

Four

THE BEST CLUB
IN CHICAGO

By 1907, Hull-House had grown from a single floor in the mansion on Halsted Street to a 13-building complex encompassing an entire city block. The settlement's activities had also expanded to include a myriad of classes, theatrical and musical programs, and a vigorous effort to eliminate the systemic causes of the poverty and despair in the area. Jane Addams continued to believe, however, that the settlement should be primarily a place where people from different social classes and ethnic origins could meet and learn from one another.

Indeed, by the turn of the century, hundreds of people came from around the neighborhood, the country, and the world every week to meet at Hull-House. They hoped to encounter like-minded people in Hull-House sponsored clubs, to escape the congestion of the neighborhood, to share a meal with friends, to discuss the issues of the day, and to experience the settlement experiment first hand. The result was that Hull-House soon blossomed into a busy, vibrant center, bustling with activity and bursting with new ideas.

For the residents of the Near West Side, Hull-House offered a space to meet with friends away from the squalid tenement houses of the neighborhood. It also organized clubs for people with similar social, political, or recreational interests. For the middle-class social reformers who lived at Hull-House, the settlement served as a place to meet not only their working-class neighbors, but other activists and intellectuals who were drawn there. The settlement soon became known as a place where one could encounter lively debate, and visitors traveled from great distances to participate in its informal intellectual life. As journalist Henry Demarest Lloyd declared, Hull-House was "the best club in Chicago."

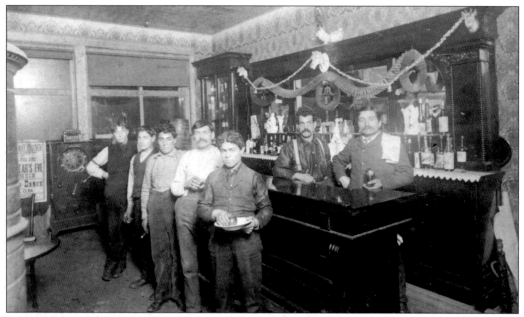

By 1900, Chicago boasted one saloon for every 60 residents in Chicago. In immigrant neighborhoods such as the 19th Ward, saloons functioned as important social centers. The saloon served as a place for workers to get good, cheap food and drink, to cash a paycheck, to meet with friends, to learn the news, and to escape the congestion of the tenement house. Saloons also provided space for such community functions as wedding receptions and funerals. (IAC 17.1)

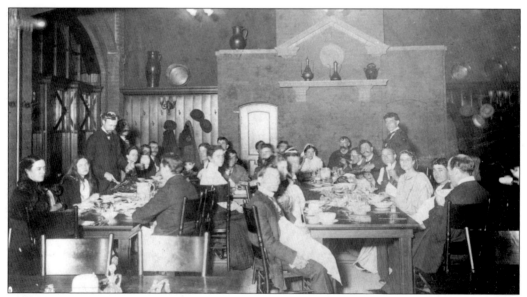

Hull-House reformers recognized the importance of local saloons as social centers. However, in the saloon, they also saw headquarters for street gangs, prostitutes, and political bosses. Though not strict temperance advocates, settlement workers deplored the effects of overindulgence in alcohol on neighborhood families. In an attempt to provide an alternative to the saloon, settlement residents founded the Hull-House Coffeehouse, which served inexpensive, nutritious food and non-alcoholic beverages. (JAMC 2638)

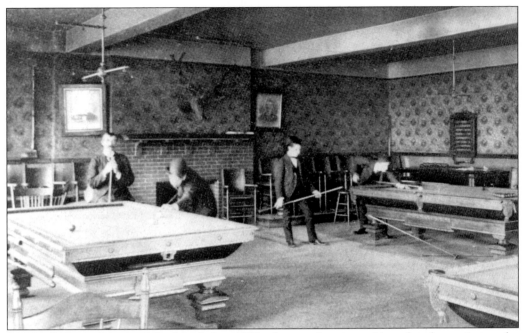

The Hull-House Men's Club, founded in 1893, also sought to provide a dry alternative to the neighborhood saloon. The clubroom was furnished with billiard and card tables. Shortly after being formed, the Men's Club could boast over 150 members. However, neither it, nor the coffeehouse could overtake the saloon in popularity in the 19th Ward. (JAMC 632)

The Newly Weds Social Club was just one of the many clubs formed by neighborhood residents. Lacking alternative places to socialize, young people in particular were drawn to Hull-House for fun and companionship. (HHA)

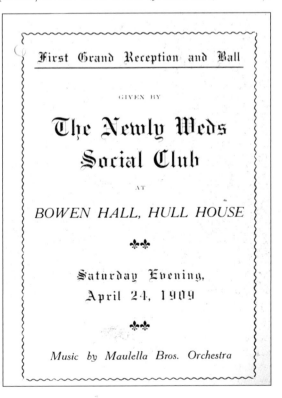

First Grand Reception and Ball

GIVEN BY

The Newly Weds
Social Club

AT

BOWEN HALL, HULL HOUSE

❖❖

Saturday Evening,
April 24, 1909

❖❖

Music by Maulella Bros. Orchestra

Hull-House resident Dorothea Moore recalled that children's clubs met in the evenings, making Hull-House a very lively place after dinner. However, "each club, no matter how lightly social, has its own sober meeting once a month when it listens to some lecture or informal talk." (JAMC 1261)

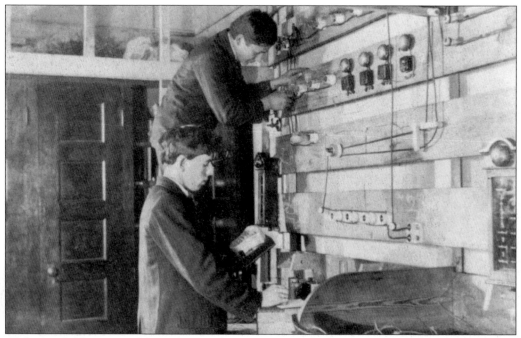

Clubs for children ranged from the social to the educational. In the Electrical Club, young boys hoped to learn a marketable skill. (JAMC 5563)

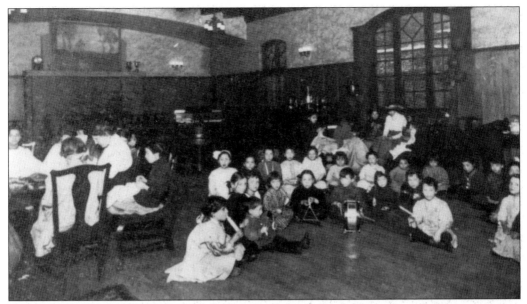

By 1902, more than 40 clubs met at Hull-House each week. To accommodate all of these activities, each of the rooms in the Hull-House complex was pressed into service. The multi-purpose rooms of the settlement were continuously being rearranged. Jane Addams' nephew John Weber Linn recalled that in the early days of Hull-House, "furniture…was constantly being shoved here and there and everywhere. It was in those days that Jane Addams acquired the habit, persistent until the end, of moving about while she conversed, shutting drawers, adjusting pictures, even shifting desks." Here the Kindersymphonie meets in the Dining Hall. (JAMC 5576)

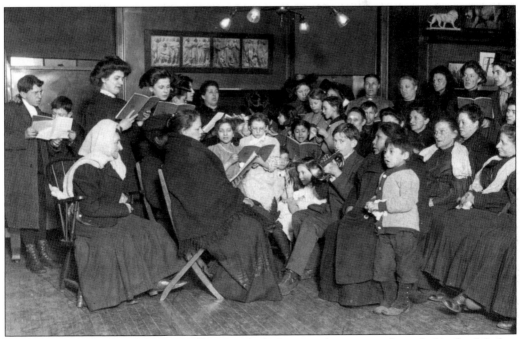

The Chicago Friendly Club, originally composed of city gardeners, was the only family club that met at Hull-House. (JAMC 1103)

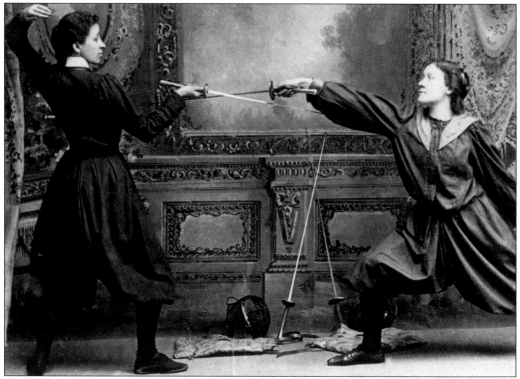

Although Hull-House gained a reputation as a center for children, neighborhood men and women also used Hull-House as a meeting place. Some organized clubs around recreational activities. The Fencing Club, for example, met at Hull-House on Tuesday and Thursday evenings throughout 1897. Women engaged in the pastime too, as seen in this staged photo. (JAMC 195)

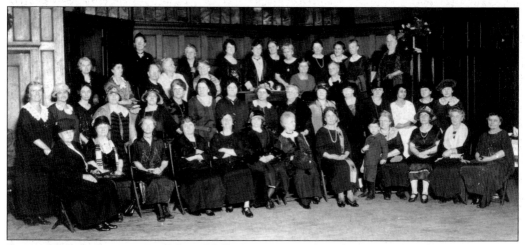

Some of the most important clubs at Hull-House were political in nature, formed to discuss the issues of the day. Organized in 1893, the Hull-House Woman's Club was made up of reform-minded women from the Hull-House neighborhood and from around the city. As one of their first activities, the club investigated the state of sanitation in the alleys near Hull-House. The Woman's Club documented 1,037 violations of public health regulations and reported them to the department of health. (JAMC 859)

As one of the first owners of a telephone in the area, Hull-House became an important communication center for the Near West Side. Hull-House residents like Mary Sullivan, pictured here, would place telephone calls for neighbors to the police, doctors, and other social service agencies. (JAMC 287)

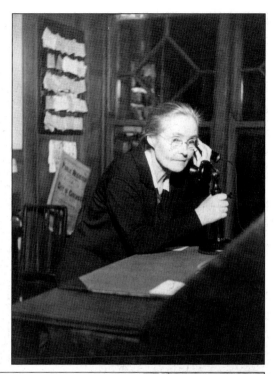

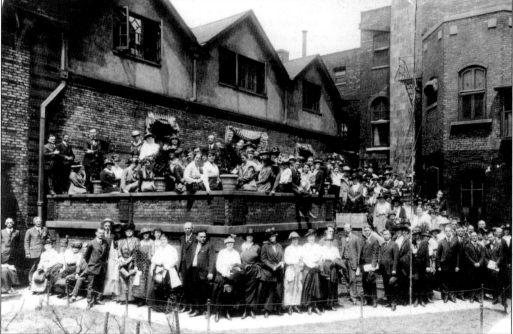

Hull-House was among the first settlement houses to be founded in the United States, but was soon joined by over 400 others across the country. As settlement pioneers, Hull-House residents were leaders in the national settlement movement. Here settlement leaders from around the United States meet at Hull-House to discuss reform efforts, programs, fundraising, and the settlement philosophy. (JAMC 1795)

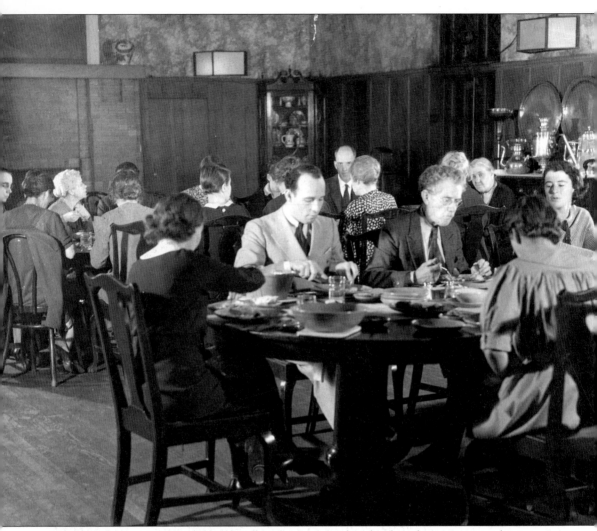

For Hull-House residents, discussion of settlement social and political issues occurred not just at conferences, but also on a daily basis. Every evening, Hull-House residents gathered around the long tables in the dining room to share an evening meal and to discuss their work. (JAMC 445)

The lively discussion in the Hull-House dining room attracted prominent Chicago intellectuals. Philosopher John Dewey and attorney Clarence Darrow, pictured here, often joined the residents for an evening meal. (Library of Congress)

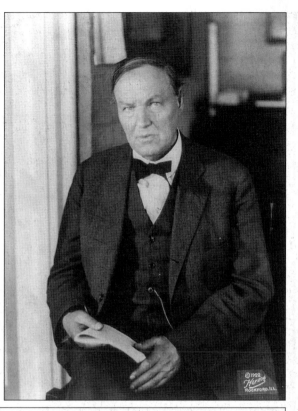

Affaires de Coeur sometimes supplanted affairs of state among Hull-House residents, most of whom were single people in their 20s. This close-knit community socialized in the evenings and more than one marriage resulted from relationships formed at Hull-House. Gerard Swope and Mary Hill met as residents and were married in 1901. Later, in 1923, residents Ada Yoder and Robert Hicks, pictured here, met and were married at the Bowen Country Club. (Kirkland)

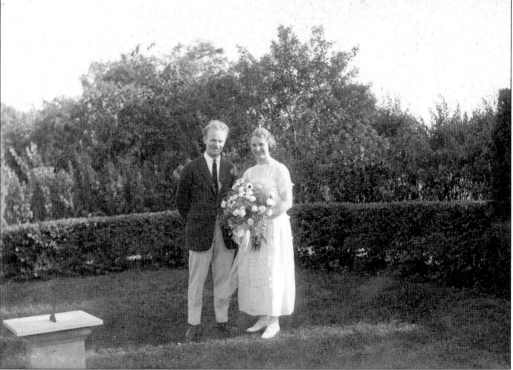

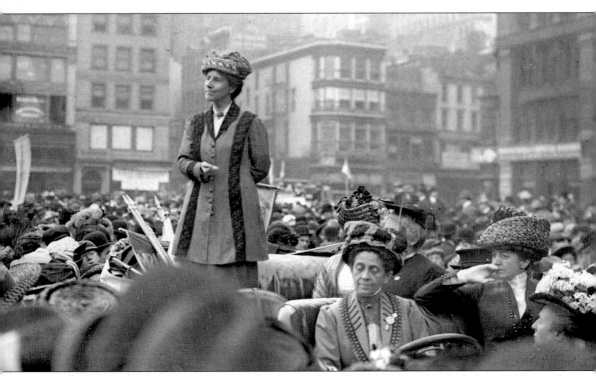

As Hull-House's reputation grew, reformers and intellectuals from around the country and around the world came to the settlement house for meetings, to give lectures, and to visit with residents. Writer and feminist Charlotte Perkins Gilman visited Hull-House in 1895, becoming friends with Jane Addams. Gilman's work on co-operative living was influenced by her experiences at Hull-House. Pictured here at a suffrage parade, Gilman was most famous for her short story "The Yellow Wallpaper." (Detail of 'New York Street Meeting. Charlotte Perkins Gilman Speaking.' The Carrie Chapman Catt Collection, Bryn Mawr College Library.)

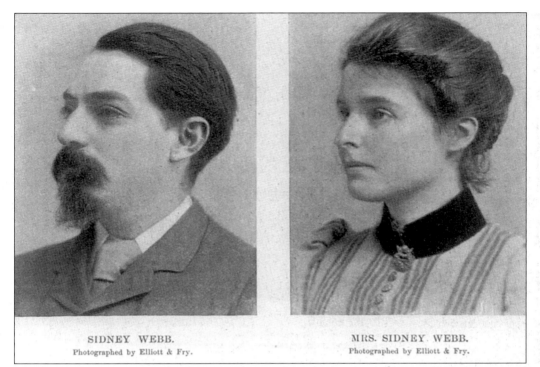

SIDNEY WEBB.
Photographed by Elliott & Fry.

MRS. SIDNEY WEBB.
Photographed by Elliott & Fry.

British socialists Beatrice and Sydney Webb visited for the first time in 1898. Though impressed with the work of Jane Addams at Hull-House, the aristocratic Webbs did not enjoy their stay. Beatrice Webb wrote that "the days of our stay at Hull-House are so associated in my memory with sore throat and fever, with the dull heat of the slum, the unappetizing food of the restaurant, the restless movements of the residents from room to room, the rides over impossible streets littered with unspeakable garbage, that they seem like one long bad dream." (Library of Congress)

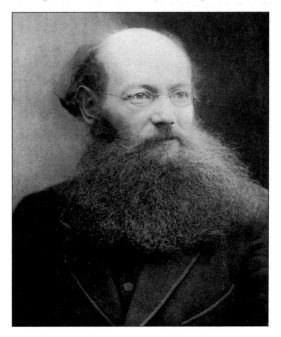

In contrast, Russian anarchist and reformer Prince Peter Kropotkin entered into the spirit of the settlement house. In her autobiography, Alice Hamilton fondly recalled Kropotkin's sojourn at Hull-House. "He stayed some time with us at Hull-House, and we all came to love him, not only we who lived under the same roof but the crowds of Russian refugees who came to see him. No matter how down-and-out, how squalid even, a caller should be, Prince Kropotkin would give him a joyful welcome and kiss him on both cheeks." (Library of Congress)

In her diary, Beatrice Webb also recalled, "there is usually scanty service, the front door being answered by the resident who happens, at the time, to be nearest to it." Indeed as the settlement house became increasingly well known, it attracted a large number of visitors who wanted to witness the social experiment first hand. The Hull-House residents soon realized that they needed to replace their ad hoc system of greeting guests with a more organized one. Beginning in 1893, residents were assigned shifts to greet visitors and to give them tours of the settlement house. This tended to be one of the residents' least favorite tasks and became known as "toting" visitors. (JAMC 1442)

For residents, including Jane Addams, right, the constant intrusion of visitors must have been disconcerting. Frances Hackett recalls one incident in which "one of the visitors caught a glimpse through the window of [Jane Addams] sitting at a table…. without waiting for an invitation or asking permission she opened the door to the dining room…'Oh girls,' she cried 'come here quickly. Here's one of them eating'." (JAMC 557)

Five

REDS, RIOTS,
AND RACKETEERS

The outbreak of the First World War in 1914 found Hull-House a firmly established institution in Chicago. The settlement complex had expanded to encompass an entire city block. Its activities—begun as ad hoc responses to neighborhood problems—had evolved into formalized programs with paid staff members supplementing the work of volunteer residents. The investigative and social reform efforts of many Hull-House residents earned them national reputations as leaders of the Progressive Movement.

However, despite its growth and increasingly formal structure, Hull-House remained a dynamic institution during the period between 1914 and 1929. Indeed, it needed to be creative to respond to the ever-changing challenges facing the neighborhood—from the privations of war, to the persecutions of the red scare and the increasing racial tensions as the ethnic make-up of the neighborhood evolved. Hull-House continued to offer services to improve the lives of its neighbors and to work toward eliminating the causes of suffering.

For Jane Addams, who had been very successful in creating real social and legislative change, the period between 1914 and 1929 proved to be a deeply disillusioning one. Profoundly committed to peace, Addams worked tirelessly and publicly to end the hostilities in Europe and to oppose the participation of the United States in the war. In the climate of wartime patriotism, her pacifist stance significantly damaged her reputation. The 1920s saw another disappointing failure from the perspective of many Progressive reformers—the Eighteenth Amendment. Nowhere was the failure of the prohibition on the sale of alcohol more clear than on the Near West Side of Chicago. The capacity of American society for reform, which had once seemed boundless, began to reach its limits in the 1920s.

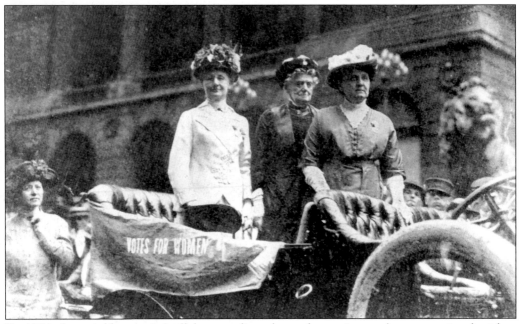

By 1914, Jane Addams was well known throughout the nation and was associated with a number of reform causes, including woman's suffrage. As the demand for her as a speaker and writer increased, she spent less and less time at Hull-House. (JAMC 1782)

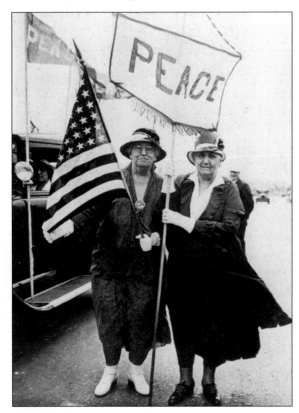

Long a pacifist, Jane Addams was appalled by the outbreak of the First World War in 1914. During the war, Addams concentrated her energies on working for peace in Europe. She became president of the Woman's Peace Party (later the Women's International League for Peace and Freedom), first advocating the end of the war by arbitration, and then opposing the entry of the U.S. into the war in 1917. Addams' opposition to the American war effort made her extremely unpopular and caused her to be labeled a traitor in the press. (JAMC 1799)

Despite Addams' opposition to the war, Hull-House participated in the war effort in a number of ways. Eight Hull-House residents volunteered for the army including Jane Addams' nephew John Addams Linn, pictured here. A contingent of the Hull-House Boys Band went to the Front to entertain the troops and Hull-House hosted a selective service recruiting station. (JAMC 1419)

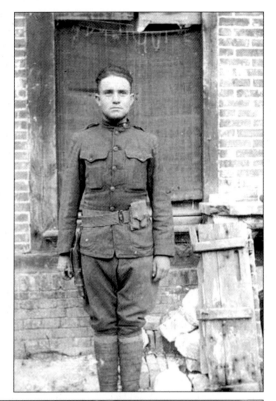

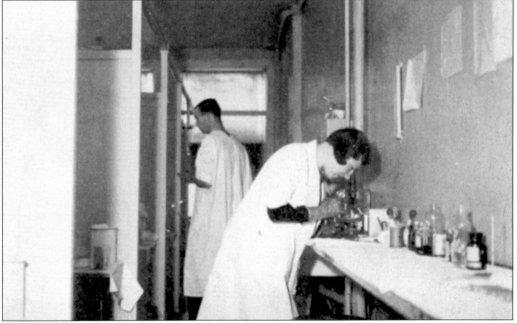

Several Hull-House residents were active in the war effort. George Hooker was head of the district Draft Board and Dr. Alice Hamilton inspected munitions factories for health and safety violations. Dr. Rachelle Yarros worked with the Social Hygiene League to educate servicemen about venereal disease. (Illinois Social Hygiene League Annual Report, 1919)

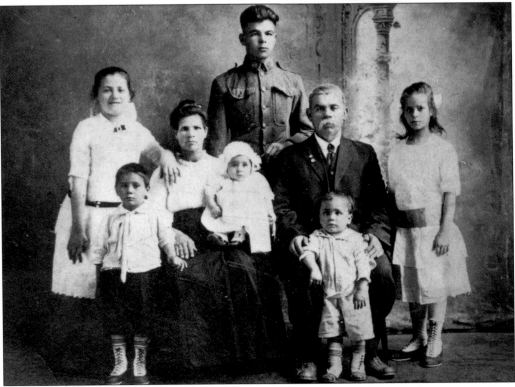

The war affected Hull-House and its neighbors in a number of ways. Many residents of the Near West Side, like the Purciarellos, lost sons in the fighting. (IAC 135.1.14)

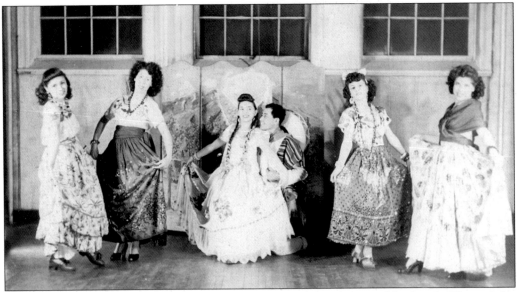

The war also contributed to the changing face of the Hull-House neighborhood. War and the 1919 Immigration Restriction Act cut off the flow of immigrants from Europe. Furthermore, wartime prosperity allowed many older residents of the Near West Side to move to the suburbs. In the early 1920s, Mexican migrants began to move into the Hull-House area.

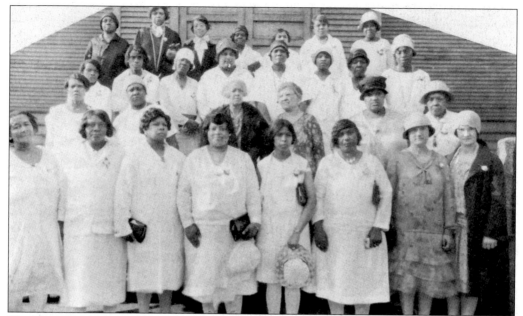

The First World War also saw the beginning of the Great Migration of African Americans from the South to northern cities like Chicago. African Americans settled to the south and west of Hull-House. The Hull-House Community Club was made up of African American women. (JUAC 5562)

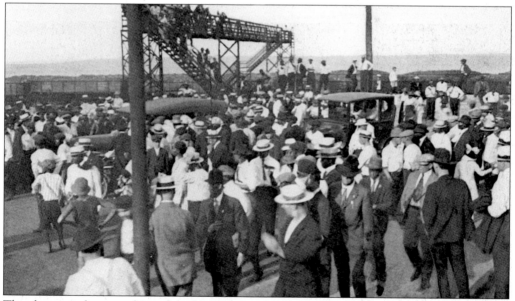

The changing demographics of the Hull-House neighborhood brought unprecedented levels of racial conflict to the Near West Side. Racial violence was not limited to the Hull-House neighborhood, however. In 1919, a riot erupted on the South Side when a group of white youths attacked and drowned a young African American boy swimming in Lake Michigan. (Chicago Commission on Race Relations)

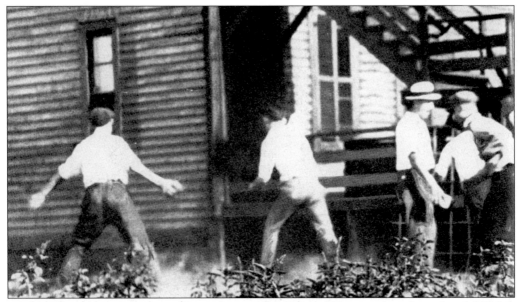

By the time the riot was over, 38 people were dead, over 500 injured, and another 1,000 left homeless. One of the most vicious murders of the riot took place only blocks from Hull-House. Acting upon a rumor that an African American youth had killed an Italian girl, an angry mob attacked a black passerby, beating him, then shooting him 14 times. Hull-House residents were shocked by the violence and the destruction of property. Jane Addams was among those who testified before the Chicago Commission on Race Relations set up to investigate the causes of the rioting. (Chicago Commission on Race Relations)

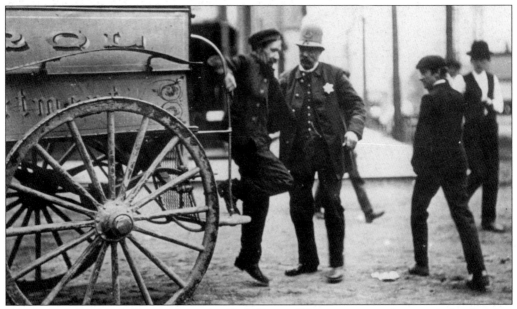

Another outcome of the war was the Red Scare. Wartime nationalism and the Russian Revolution launched a period of anti-communist hysteria in the United States. Hull-House's immigrant neighbors were vulnerable targets for authorities in search of communist sympathizers and Hull-House was known for tolerating political radicals. (JAMC 293)

While Chicago police were eager to round up suspected "Bolsheviks," they would prove to be unenthusiastic about pursuing violators of the Prohibition of the production, sale, and consumption of alcohol that went into effect in 1920. Jane Addams and many Hull-House reformers had long been temperance advocates. However, the lawlessness and gangsterism ushered in by Prohibition convinced Addams that the Eighteenth Amendment had been a failure. This photo shows the Hull-House dining room decorated for a temperance event. (JAMC 161)

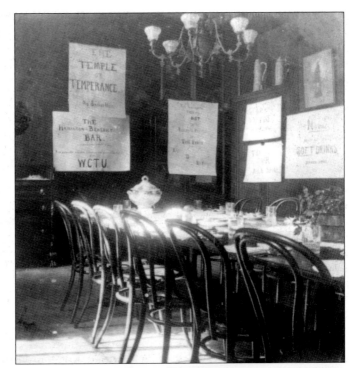

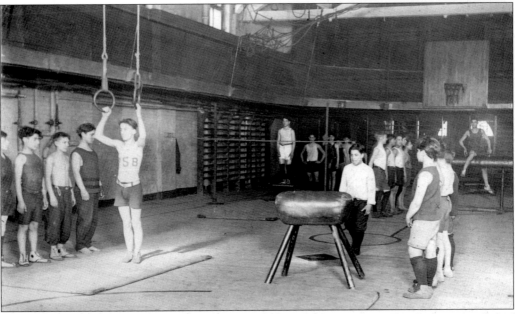

Prohibition was a boon to organized crime in Chicago and rival gangs fought over control of the production, distribution, and sale of illegal alcohol in the city. Several of these gangs were headquartered in the Hull-House district and some members were active participants in Hull-House activities. Boys' Club director Wallace Kirkland recalled that one club member became a "collector" for the syndicate. "When he came to Hull-House for gym classes, he would hand me his roll of bills for safe-keeping. Soon after his wedding…he was 'taken for a ride' by competing bootleggers." (JAMC 197)

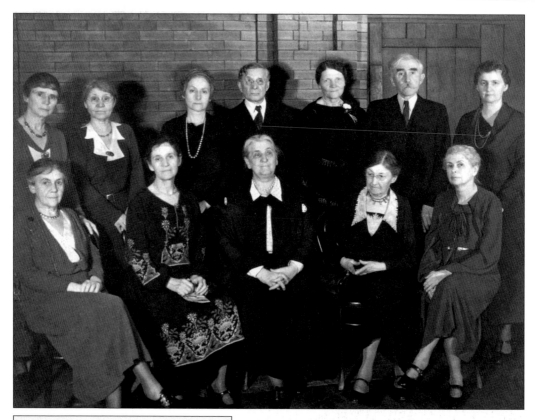

The decade of the 1920s was one of transition for the settlement house. In addition to the prolonged absences of Jane Addams, the settlement suffered from the loss of many of its early leaders. Alice Hamilton left Hull-House for Harvard Medical School and Sophonsiba Breckinridge for the University of Chicago. Julia Lathrop moved to Washington to head the Federal Children's Bureau. The remaining leaders, pictured in this 1930 photo, were aging. (JAMC 450)

Ellen Gates Starr moved out of Hull-House into a Catholic convent in 1929 after a spinal operation left her paralyzed. However, Starr had been drifting away from the Hull-House circle some time before her final departure from the settlement house. Starr and Addams began to grow apart in the 1890s as Mary Rozet Smith became Jane Addams' most important confidant. Further, Starr's socialism and labor radicalism conflicted with the non-confrontational philosophy adopted by Addams. After much searching, Starr found the spiritual fulfillment that she had sought at Hull-House in the Roman Catholic Church, converting in 1920. (JAMC 3564)

Hull-House responded to the social upheaval of the war years and the 1920s by continuing to conduct investigative studies of the neighborhood, to push for legislative reform, as well as to offer practical services and recreational programs for neighbors. In the 1920s, Hull-House documented changing immigration patterns in studies of the Greek, Mexican, Italian, and Romany populations. Known as "gypsies" in the 1920s, many Roma people, including those pictured here, lived for a time in the Hull-House neighborhood. (OTSC)

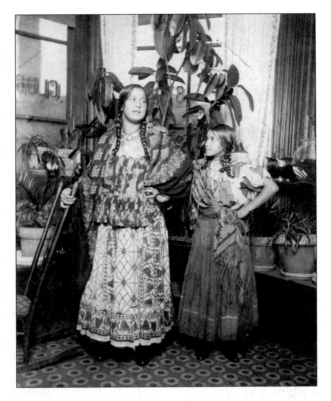

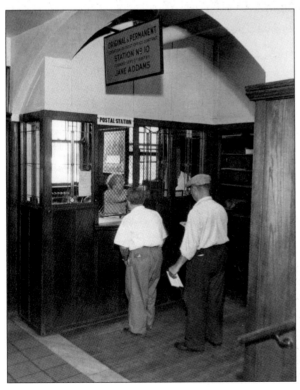

Hull-House residents discovered that many of their neighbors sent money to their families in Europe through ethnic agencies. These local brokers often charged exorbitant commission for their services. To offer an alternative to exploitative local agents, Hull-House became a branch station of the federal post office. (JAMC 3603)

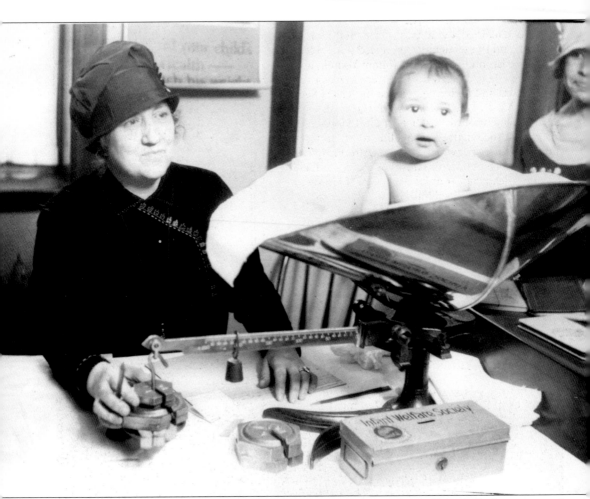

On a national scale, settlement workers saw the fruits of their reform efforts with the passage of the Sheppard-Towner Maternity and Infancy Act of 1921, which provided for pre- and post-natal education for mothers. The Act was the first social welfare legislation ever passed in the United States. The investigative work of the federal Children's Bureau—founded in 1912 at the urging of settlement leaders and headed by former Hull-House resident Julia Lathrop—was instrumental in persuading Congress of the need to better protect the health of mothers and children. (JAMC 3603)

The arts remained a vital part of the Hull-House program and the settlement produced some well-known artists and performers. Jimmy Yourell, a young newsboy, danced his first steps in classes at Hull-House and performed in *The Enchanted Swans* and *The Mask of the Seasons*. With the encouragement of his teachers at Hull-House, Yourell pursued dance by traveling to Milan to study with the renowned ballet maestro Enrico Cecchetti. Yourell, later known as Vincenzo Celli, became a lead dancer at La Scala Opera House in Milan. He returned to Hull-House in 1929 to perform and assist in classes. (HHA)

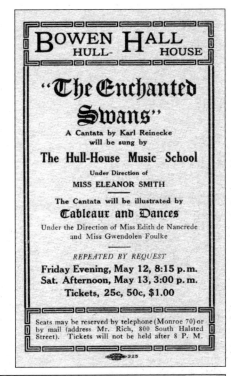

BOWEN HALL
HULL-HOUSE

"The Enchanted Swans"

A Cantata by Karl Reinecke
will be sung by

The Hull-House Music School

Under Direction of
MISS ELEANOR SMITH

The Cantata will be illustrated by

Tableaux and Dances

Under the Direction of Miss Edith de Nancrede
and Miss Gwendolen Foulke

REPEATED BY REQUEST

Friday Evening, May 12, 8:15 p.m.
Sat. Afternoon, May 13, 3:00 p.m.
Tickets, 25c, 50c, $1.00

Seats may be reserved by telephone (Monroe 70) or by mail (address Mr. Rich, 800 South Halsted Street). Tickets will not be held after 8 P. M.

325

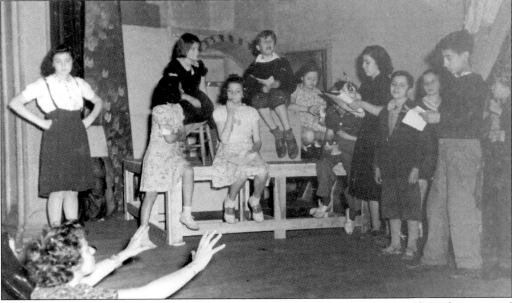

In 1939, Viola Sills (Spolin) directed the Junior Theater Group in *Brave Little Tailor*, pictured here. From 1924 to 1927, Sills studied at the Recreational Training School directed by Neva Boyd at Hull-House. Sills credited her training in games, story telling, folk dance, and dramatics with inspiring her to create sets of theater games designed to release inhibitions and free the creativity of aspiring actors. At Hull-House, she supervised creative dramatics for children and directed experimental theater groups. Her son, Paul Sills, drew on these theater games when he co-founded Chicago's Second City theater company in 1959. (JAMC 4376)

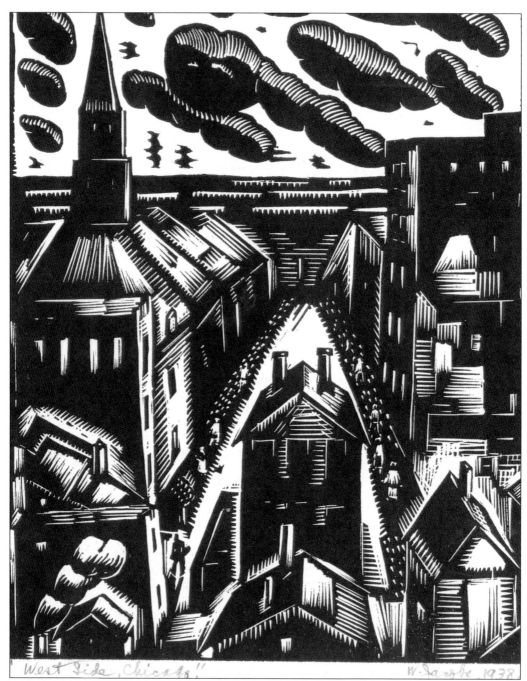

"West Side, Chicago" W. Jacobs 1938

In the 1920s and 1930s, artists who had studied at Hull-House as children or young adults returned to teach and create art in the stimulating environment of the settlement house. Their work reflected a willingness to experiment with styles, techniques, and subject matter. Morris Topchevsky and Emily Edwards studied in Mexico with Diego Rivera and were inspired by both the art and the politics of Mexico. Leon and Sadie Garland's cubist-inspired style reflected their European studies. William Jacobs created boldly graphic depictions of the city, including this print of the Hull-House neighborhood. (HHA)

Six

A RIOT OF
YOUNG PEOPLE

In the evenings, according to resident Dorothea Moore, Hull-House became "a riot of young people." Released from school or work, youngsters sawed and hammered in vocational training classes, danced in the Hull-House gymnasium, or happily chattered away in one of the many social clubs. Like many Hull-House programs, activities for children initially emerged spontaneously, as curious children stopped in to investigate their new neighbors. Jane Addams, however, soon developed a new perspective on the needs of children based upon advances in theories of childhood development and on her own first-hand experiences in the Hull-House neighborhood. Her ideas became a foundation upon which Hull-House programs for children and young adults were built.

As educators and psychologists studied the development of children in the late 19th and early 20th centuries, they concluded that childhood represented a special time of growth that shaped future character and behavior. In particular, the adolescent years were a dangerous time during which the energies of youth needed to be constructively directed. Settlement residents viewed the modern city as especially threatening to proper adolescent development. In *The Spirit of Youth and the City Streets* (1909), Jane Addams noted that at a time when work had become its most monotonous, the city had abandoned its traditional practice of sponsoring safe, healthful, and family-oriented recreation. Commercial dance halls and movie palaces stimulated the senses without fueling imagination or creativity and provided unrealistic or inadequate moral and social guidance. The community, she believed, must take responsibility for feeding the need for adventure, the thirst for social righteousness, and the instinct for play that marked the adolescent years.

Settlement houses, given their intimate contact with the families of their neighborhood, stood in a unique position to influence and guide this development. Disillusioned by their own generation's apathy toward social reform, settlement residents enlarged and expanded their programs for children in the post-war years. The Mary Crane Nursery addressed early childhood development and physical health as a precursor to mental and emotional health. In arts programs, the Hull-House Boy's Club, and Bowen Country Club, Hull-House nurtured the "play instinct" through activities that stretched imaginations and expended physical energies. Addams believed that all of society would ultimately benefit as the joy in life learned as an adolescent produced creative and socially responsible adults.

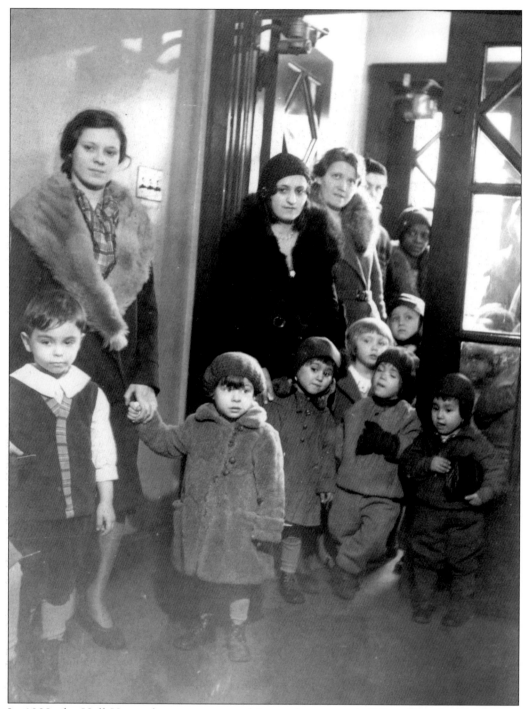

In 1908, the Hull-House day nursery moved into a large, new building. Run for 18 years by United Charities of Chicago, the Mary Crane Nursery accommodated 100 children. The program included a baby clinic, a playroom for the children of working mothers, and classes "where the most untutored and bewildered mothers receive rudimentary instruction in the methods of American housekeeping." (JAMC 1183)

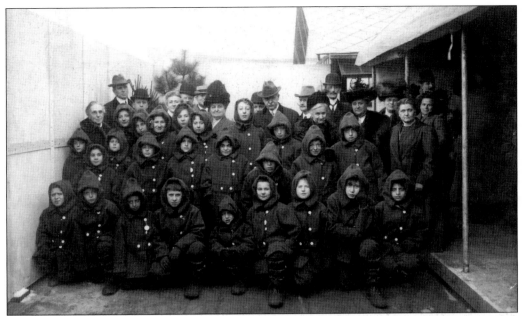

An open-air school for delicate children began on the roof of the Mary Crane Nursery in 1909. A public school teacher conducted classes in the bracing Chicago air and children napped in open tents. Health professionals believed fresh air prevented tuberculosis. In 1920, the program moved to the neighboring Dante School. Bowen Hall sported a flower and vegetable garden on its roof. (JAMC 143)

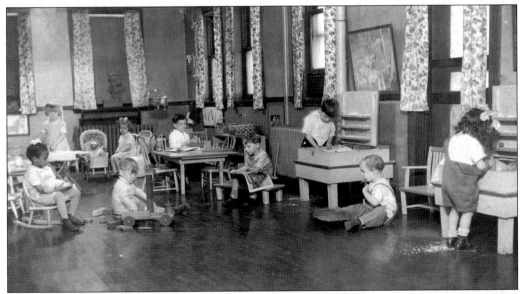

In 1925, under administration by the National College of Education in Evanston and several cooperating agencies, the nursery school became a demonstration center for the integration of parental and children's education. Personal conferences, home visits, and a weekly class educated mothers in childcare. The predictable routine of the all-day program for children established an atmosphere of security believed necessary to wholesome and carefree development. Music, art, and storytelling activities fostered self-expression and social skills. (Kirkland)

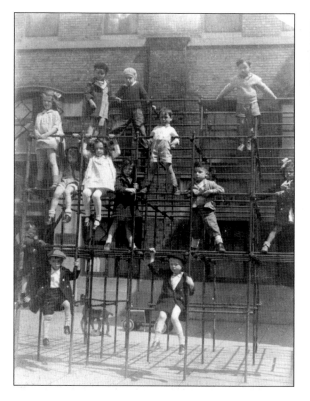

Outdoor play encouraged healthy bodies and children scampered up the monkey bars outside the Mary Crane Nursery during outdoor recreation times. (JAMC1125)

Staff provided by the Elizabeth McCormick Memorial Fund weighed and examined neighborhood children once each month. They conducted weekly nutrition classes for older brothers and sisters of nursery school students and offered healthcare for graduates of the school. (MCL)

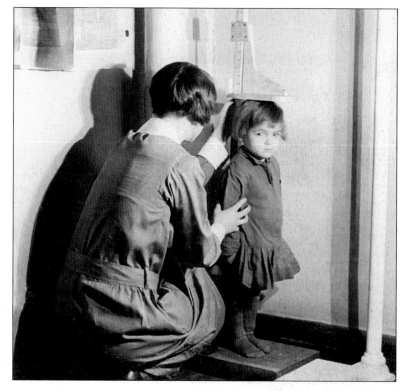

To compensate for inadequate sunlight in the urban environment, nurses provided by the Infant Welfare Society administered more than 600 artificial sunlight treatments each month to children. (JAMC 2087)

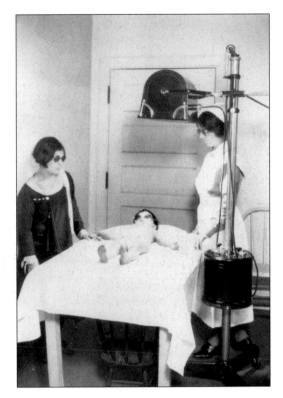

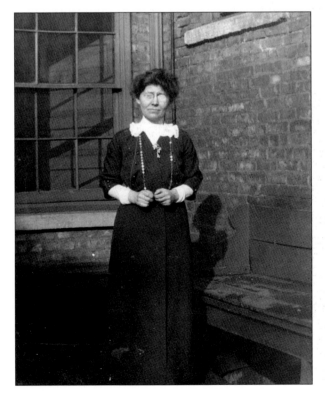

Hull-House resident Dr. Rachelle Yarros operated a family planning center within the Mary Crane Nursery. Yarros believed excessive childbearing was a factor in poverty and ill-health but unlike some advocates of birth control she rejected the idea that birth control should be used to ensure the numerical superiority of the upper classes. Education was the key to Yarros' approach and she worked with Hull-House to establish sex education programs for young people. (JAMC434)

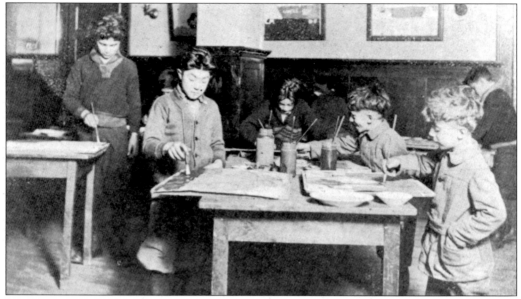

In 1921, artist Norah Hamilton, sister to Dr. Alice Hamilton, reorganized and expanded the children's art program. She conducted classes to evoke the spirit of play through pleasurable, social experiences designed to encourage spontaneity and originality of expression. (JAMC 5606)

Hull-House instructors believed the true aesthetic experience occurred during the process of creation, not in the final product. Teachers focused on creating an environment conducive to freeing this creativity in a variety of mediums. In the 1920s, the Hull-House Art School taught classes in pottery, clay modeling, woodworking, painting, embroidery, puppetry, crafts, and block printing. (JAMC 582)

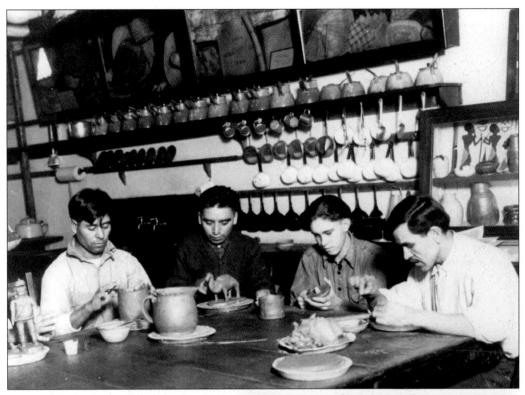

Jane Addams thought young adults needed the stimulus of monetary return to encourage them to continue with their artwork. In 1927, Hull-House's early pottery efforts were reorganized to include the Hull-House Kilns. Directed by ceramicist Myrtle Merritt French, the Hull-House Kilns produced tableware and figurines in bright glazes for sale at the Hull-House shop. Mexican potters became creative producers and respected teachers for the Hull-House Kilns. (JAMC439)

Young Nick Fosco watched the potters at work on his way to and from the Hull-House gymnasium, where he practiced boxing. After he began pottery lessons, his gang escorted him to class but would not stay to watch, lest they be mistaken for artists. Fosco eventually became both a foreman in the Kilns and a Golden Gloves boxing champion. Fosco and a friend are pictured re-lining the Hull-House kiln. (JAMC 938)

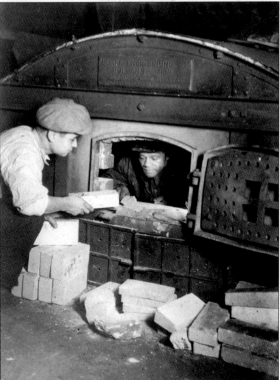

Soon after arriving at Hull-House in 1898, artist Edith deNancrede discovered that she preferred "to make pictures for the stage." Nancrede directed social clubs that focused on dramatic activities—staging fairy tales, classics, and contemporary plays appropriate to age and developing skills. Nancrede encouraged her group members to become well-rounded by participating in Hull-House's music, dance, and art programs. She staged several productions that drew on the talents of all of these departments. Many members stayed with their groups long into adulthood. The Mignonette group is pictured here. (JAMC4522)

In the 1920s, Katherine Pearce taught classes incorporating dance with athletics to develop muscular control, free the body from tension, and express emotion. Interpretive dance allowed women to act as their own choreographers. Neighborhood resident Eleanor Farwell, who studied rhythmic dance with Pearce recalled, "We would act out what we thought the music told us to do." (JAMC 4792)

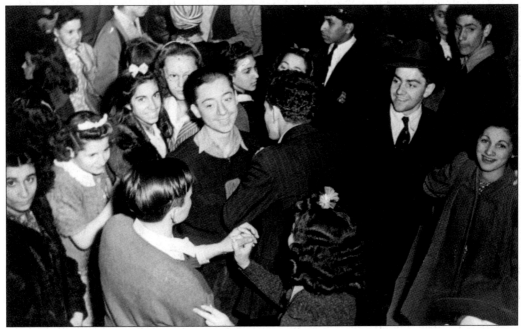

The popularity of urban dance halls alarmed Hull-House residents. A 1917 study by the Juvenile Protective Association found couples engaged in such suggestive dances as "The Stationary Wiggle" and "Shaking the Shimmy" in largely unsupervised halls that served alcohol. As an alternative, Hull-House sponsored dance classes and tightly supervised social dances. By 1921, they relented and began to teach the new dances. (3788)

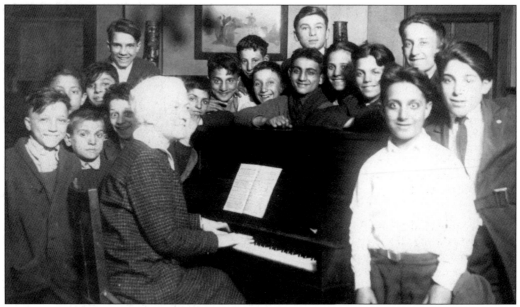

Many settlement programs placed special emphasis on those they felt most endangered by urban city life—young boys. "Sing and you'll be good" was music teacher Martha Scott's motto. "I am satisfied that good music is one of the most potent factors in the world in molding character, just as I believe it curbs unrest and prevents labor trouble in the industries . . . It must be good music. Jazz expresses hysteria and incites to idleness, revelry, dissipation, destruction, discord, and chaos." (JAMC 627)

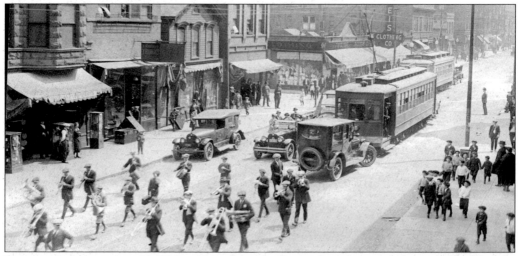

Despite these concerns, Hull-House unintentionally incubated several future jazz musicians. Art Hodes, a young Russian-Jewish student in the Music School was switched each week from alto to soprano to bass. Later, as a jazz musician, he credited his ability to hear at least three parts to a tune to the rather disturbing experience. Hodes had his first jam session ever with a young clarinetist, Benny Goodman. Goodman was a member of the Hull-House Boy's Marching Band, one of the many boys' bands created throughout the country in response to a perceived 'boy problem.' Bassist Milt Hinton, another future jazz great, traveled from the South Side to Hull-House in 1923 for music lessons. (Kirkland)

When a university student living at Hull-House encountered an industrious gang of boys building a clubhouse from materials found in the alleys, he encouraged them to visit the settlement. After rejecting the name Bloody Hen, they eventually formed a club called Silver River. Hull-House actively sought out neighborhood gangs and invited them to participate in the settlement, believing that structured activities would change the nature of the gang. (JAMC 112)

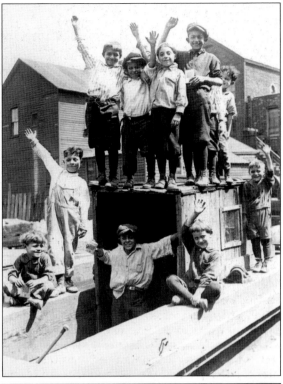

The five-story Hull-House Boy's Club contained bowling alleys, a poolroom, games room, band room, library and study room, classrooms, clubrooms, and manual training shops. Open in the afternoon for students and in the evening for working boys, the club offered a wide range of activities to keep youth off the street. More than 1,000 participants enrolled in the Boy's Club. (JAMC 253)

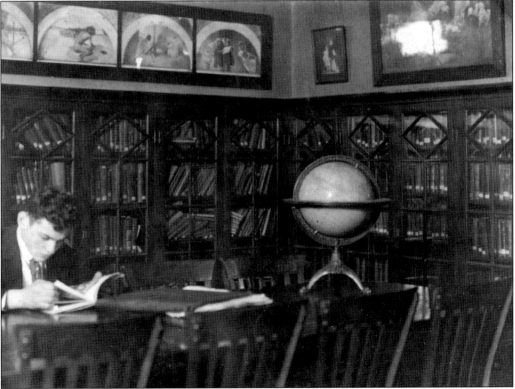

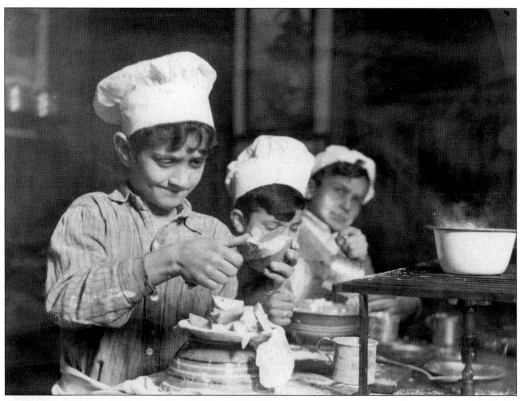

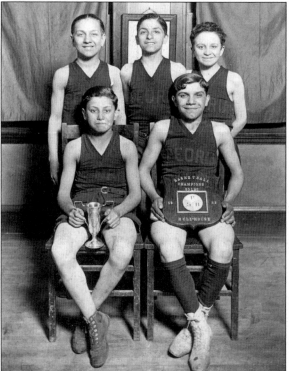

The Club also conducted cooking classes for boys. The class in camp cooking for hikes and camping trips was especially popular. The members put their cooking skills to use on numerous outings conducted by the Boy's Club. (JAMC 1142)

A number of winning teams developed in the athletics program of the Boy's Clubs. Shown are the Peoria Sport Boys, named for the street on which they lived. The Sport Boys won the Hull-House Basketball Championship and graduates of the group edited and published a newspaper, *The Hull-House Tatler*. (JAMC 2692)

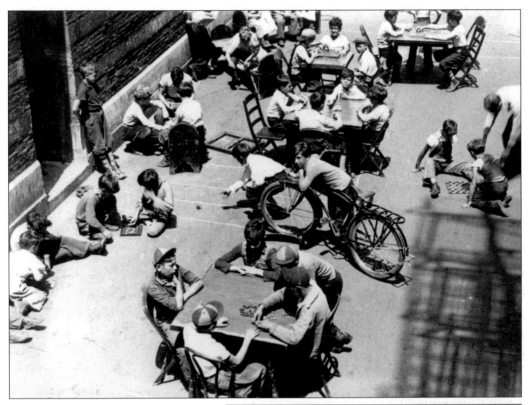

Beginning in May, the boys spilled out into the streets. Supervised play in the Hull-House alley kept young children away from traffic in the city streets. Hull-House residents taught various board games and ensured that each child was included in games. (JAMC 1045)

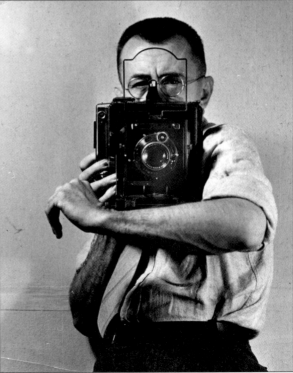

In the 1920s, the Eastman Kodak Company presented the Hull-House Boy's Club with a 5 x 7 view camera. After learning to use the camera, Club Director Wallace Kirkland taught photography in a well-equipped studio and dark room on the third floor of the Boy's Club. Kirkland's photographs of Hull-House documented activities at the settlement during the 1920s and 1930s. He later became a photographer for *Life* magazine. (Kirkland)

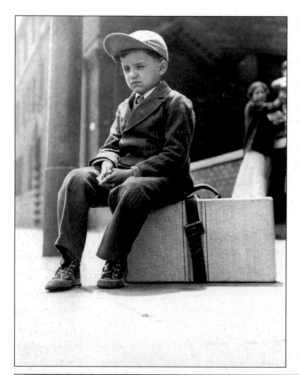

Neighborhood children eagerly awaited a two-week stay at Bowen Country Club, Hull-House's summer camp. Located 32 miles from Chicago on a ridge overlooking Lake Michigan, the trip necessitated an exciting train ride that took many of the children out of the city for the very first time. (JAMC 4805)

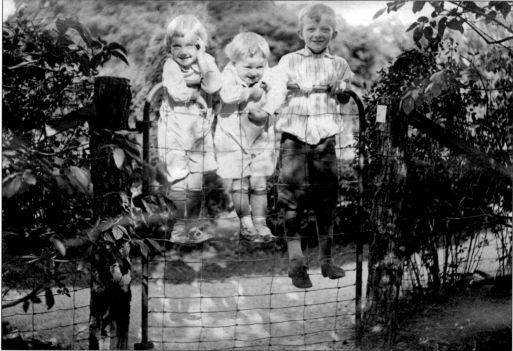

Built and endowed by Louise deKoven Bowen in 1912, Bowen Country Club sought to provide a refuge from the dirt and summer heat of the city and a chance for urban children to experience nature. A small fee removed the stigma of charity and encouraged children to feel the camp belonged to them. However, no child was turned away for inability to pay. (Kirkland)

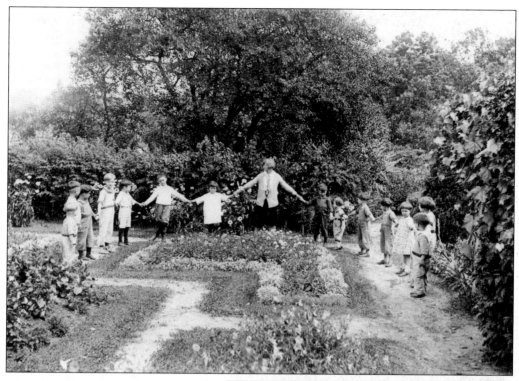

Rejecting the idea of a rough and rustic retreat, Bowen Country Club had landscaped gardens, an orchard, vegetable gardens, and a long grape arbor separating it from the surrounding fields. Bowen provided an endowment for a professional gardener to care for the grounds. This photograph shows a group of children in the formal gardens. (JAMC 1173)

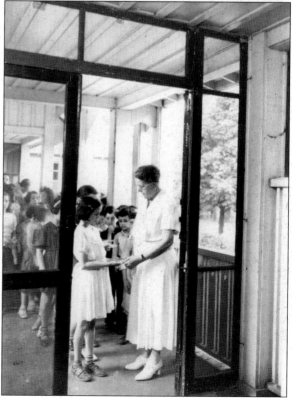

Thora Lund directed the camp from 1912 to 1938. Here, she checks the hands of a child on her way into dinner. Campers received three meals a day, family-style, on Blue Willow china at tables set with fresh flowers. "You could eat all you wanted," recalled one camper, "and all that milk. You could drink all the milk you wanted. The kids just couldn't believe it." (JAMC 1176)

Bowen Country Club welcomed the mothers of small children to stay with their little ones at Rosenwald Cottage, believing they too would be refreshed by a stay in the country. (JAMC 4521)

Located across a wild-flower carpeted ravine with a stream at its base, the more rugged Camp French for older boys originally contained tents set up in the midst of the wooded forest. In 1920, a barracks-like dormitory was built. (JAMC 1284)

Seven

COPING WITH CRISIS

The Hull-House neighborhood benefited little from the prosperous 1920s and was devastated by the Great Depression ushered in by the stock market crash of 1929. Already high levels of unemployment on the Near West Side soared and by the early 1930s neighborhood residents faced the real threat of homelessness and starvation. Identifying ways to help their neighbors feed their families, find employment, or cope with enforced idleness overshadowed other Hull-House programs. It quickly became apparent that the efforts of settlement houses and private charities were insufficient for the overwhelming needs of the unemployed and their families.

After Franklin Delano Roosevelt's election, Hull-House supported and benefited from several New Deal initiatives, which encompassed many of the reforms the settlement had long promoted. Hull-House alumnae and friends Frances Perkins, Harold Ickes, Gerard Swope, and Sidney Hillman served in the new administration. Hull-House board member Grace Abbott led lobbying efforts to include infant and maternity, crippled children's, and dependent children's services in the Social Security Act of 1938, the first permanent commitment to relief and welfare by the federal government. Works Progress Administration and National Youth Administration workers supplemented the Hull-House staff by teaching art, theater, weaving, and vocational training.

In the midst of the Depression, Hull-House received another crippling blow. Head resident Jane Addams died on May 21, 1935, leaving the settlement grief-stricken and directionless. Two subsequent settlement leaders struggled to keep programs afloat in the face of a funding crisis and an expanded need for services. Adena Miller Rich, head resident from 1935–1937, strove to retain the spirit of the settlement as it had existed under Addams and Starr, while still responding to ever-developing crises. Charlotte Carr, her successor, sought to break the stranglehold of the past and fashion a new program for the new age. Both head-residents tangled with an assertive Hull-House Board that demanded an increased role in decision making. Throughout the 1930s, the settlement continued to serve the neighborhood through services, classes, and recreational activities while trying to redefine its role for the future.

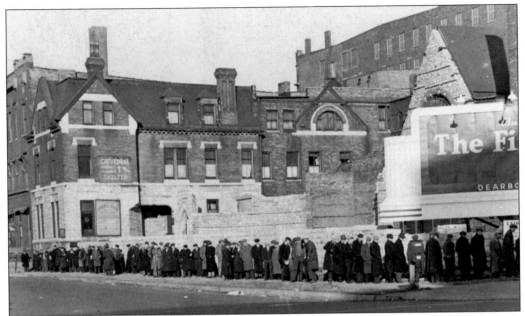

By 1932, the unemployment rate in the city of Chicago had jumped to 40 percent. Those with jobs labored for only half their former incomes. Many Chicagoans lost their homes to banks as foreclosures in the city jumped from 3,100 in 1929 to 15,200 in 1932. Many more were evicted for failing to pay the rent. Soup kitchens, "bread lines," and long waits for beds in local shelters became a common sight. (JAMC 339)

In response, Hull-House turned its attention from reform to relief efforts. When neighbors began to be evicted, settlement residents extended loans for rent payments. When the poorest neighbors were forced to forage in garbage dumps, the settlement distributed food. Over 100,000 families applied for food at the settlement in the first two months of 1932. (JAMC 5668)

Addressing unemployment became a top priority. In 1932, the League for Industrial Democracy and the Hull-House Men's Club cooperated in forming two ethnic locals of the Workers Committee on Unemployment that met at Hull-House. Hull-House worked with several agencies to find jobs for the many unemployed laborers and factory workers. The settlement also created jobs. Resident Frank Keyser supervised painting, cleaning, and repairs of the Hull-House buildings by local unemployed men. (JAMC 2081)

Recreational activities increased to provide distraction for those out of work. The Hull-House Youth Institute addressed the needs of unemployed youth by sponsoring the Lazareff Theater group. It was directed by Maria Astrova Lazareff, co-founder of the Maxim Gorky Theater in Moscow and the Chicago Art Theater. The Hull-House courtyard also hosted outdoor films for unemployed Mexican and Italian families and the Club Recreativo held two fiestas with music each month. (JAMC 3979)

Although Jane Addams backed Herbert Hoover's reelection bid in 1932, she supported New Deal measures under Franklin Roosevelt. Addams spoke out in favor of the National Recovery Administration, one of the first New Deal agencies. She was a vice-president of the American Association for Social Security and headed a public housing advisory committee in Chicago. However, Addams did not live to see passage of the Social Security Act in August 1938, nor the dedication of the Jane Addams Homes public housing project in 1935. (*Chicago Housing Authority Annual Report*, 1957)

During the 1930s, several New Deal supporters visited the settlement house. First Lady Eleanor Roosevelt, Secretary of Labor and former resident Frances Perkins, and New York Mayor Fiorella LaGuardia were among the guests. LaGuardia is pictured (left) with an unidentified woman at Hull-House. (JAMC 3780)

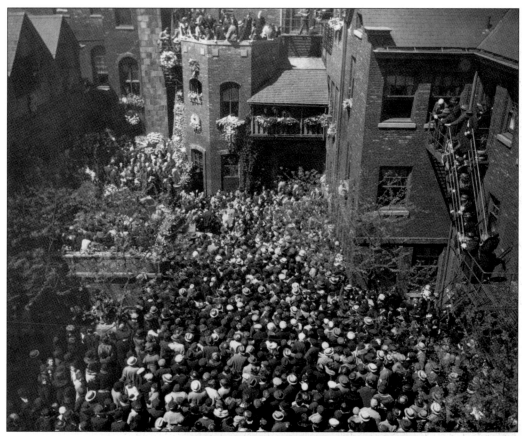

Jane Addams' death on May 21, 1935, from cancer devastated settlement residents and elicited telegrams of sympathy from around the world. Mourners arrived as early as 5 A.M. as Addams lay in state in Bowen Hall. The Hull-House courtyard was festooned with flowers for the funeral and the attending crowd spilled out into the streets. Addams was buried in Cedarville, Illinois, her childhood home. Following her wishes, her headstone listed the two most important accomplishments of her life: Hull-House and the Women's International League for Peace and Freedom. (JAMC 1813, 1829)

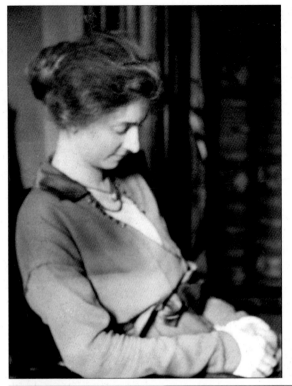

Addams' death threw the settlement into turmoil. No plans had been made for a successor and the sense of crisis was exacerbated by the pressing problems of the Depression. The residents and Board chose Adena Miller Rich as Hull-House's new head. A longtime resident with her husband Kenneth, Rich directed the Immigrants' Protective League. She chose to retain the position and devote half time to the job of head resident. (JAMC f. 511)

Under Rich, the settlement focused on issues affecting immigrants. A new Department of Naturalization and Citizenship cooperated with the Immigrants' Protective League to educate neighbors in the responsibilities of citizens for housing, sanitation, public health, and crime prevention. A Committee on International Relations focused on the connections between the homeland problems of immigrants and the settlement. (JAMC 1849)

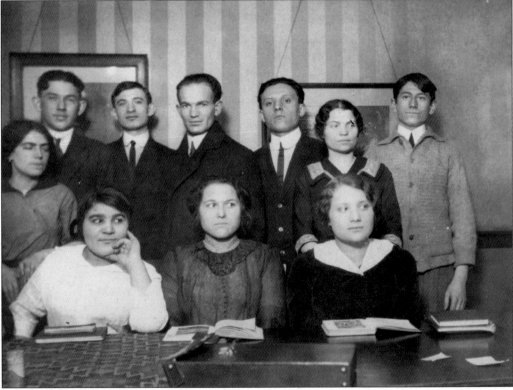

To commemorate Addams, the Octagon Room was redesigned as a memorial room containing honorary degrees, Addams' books, and photographs. Rich had promised to carry on in the tradition of Addams. "I shall follow Miss Addams' idea that the house be conducted on a family basis rather than institutional." One newer resident, however, later wrote that the settlement house stagnated during Rich's tenure. Older residents snubbed newer ones and evoked Addams' memory when rejecting all change. (JAMC 2967)

JANE ADDAMS MEMORIAL ROOM, HULL-HOUSE, CHICAGO

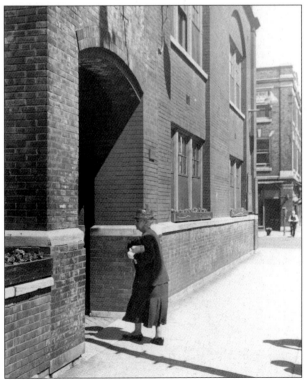

Adena Miller Rich resigned as head resident after only two years. Rich had disagreed with the Hull-House Board and its powerful president, Louise deKoven Bowen, over issues of financial and administrative control. Under pressure from the Community Fund, the Board insisted the position of head resident be a full-time, paid position. Rich responded, "This head resident's freedom is not for sale" and submitted her resignation. At left, Board President Louise deKoven Bowen enters the Hull-House buildings. (JAMC 3381)

97

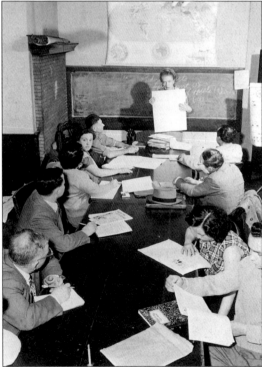

The Hull-House Board chose Charlotte Carr as the new head resident. Carr had no settlement experience but as administrator of New York City's emergency relief bureau had run a complex, massive budget program, a qualification valued by the finance-conscious board. She immediately brought change. Convinced the settlement was unresponsive to current neighborhood issues, Carr reorganized programs with a new focus on assisting neighbors in solving their own and the community's problems. (JAMC 3426)

Carr created a new Workers' Education Department as the centerpiece of her tenure. Classes and discussion groups focused on collective bargaining, public speaking, consumer issues, government and labor laws, and civic responsibility for neighborhood and political conditions. Carr hoped that every program in the settlement would eventually relate to the Workers' Education Department. (JAMC 644)

The Community Relations Department directly supported neighbors in their own efforts to improve conditions. As a result of community action, 2,000 new garbage cans were purchased and placed in the neighborhood's alleys. Neighborhood committees pressured the city for efficient pick-up. (JAMC 3232)

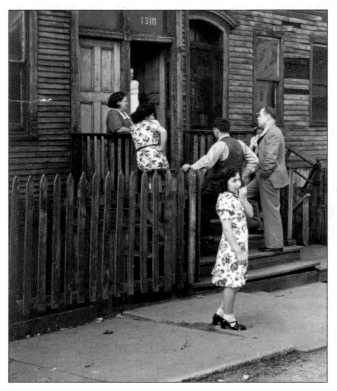

Resident Bert Boerner headed the Community Relations Department. When the Jane Addams Homes public housing project wanted to expand to the west, Boerner went door-to-door in the neighborhood to provide 'impartial' information on selling homes to clear the property. (Detail of JAMC 302)

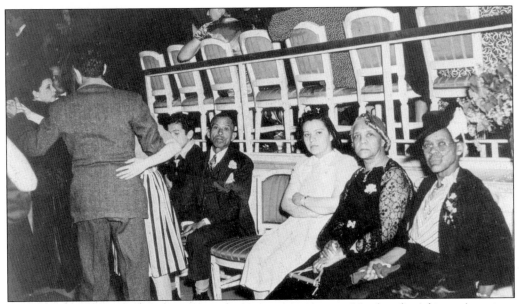

Carr accused the settlement of seriously under-serving the neighborhood's African American population. She recruited journalist Dewy Jones and his wife Faith as settlement residents. Jones alleged that while African Americans were not barred from Hull-House programs, no active program of recruitment existed. When the Woman's Club offered to host a dress ball at a downtown hotel as a fund-raiser in 1941, Carr insisted that Mexican and African American neighbors be included. The Lilac Ball attracted over 1,000 people. (JAMC 3877)

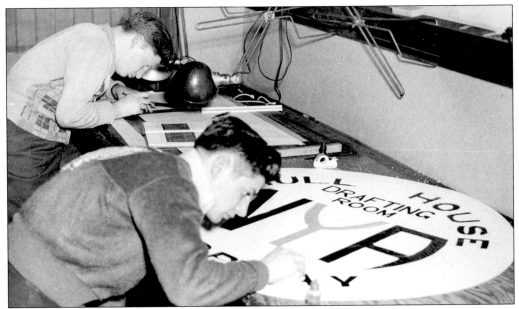

During the New Deal years, relief workers from the Works Progress Administration (WPA) and the National Youth Administration (NYA) staffed workshops that created modern machine-made articles, painted murals, taught drafting, and developed new silk screening techniques. The relief program's goals of providing work while connecting art to daily life and bringing it to the masses meshed well with Hull-House philosophy. (JAMC 94)

Carr reshaped the arts programs to reflect her belief that artists should work to solve concrete, neighborhood problems. In 1939, the Art Department and the Illinois Art Project collaborated to establish the Hull-House Art Center and Design Workshops. Classes taught by well-known artists worked on problems in graphic arts, architecture, furniture design, ceramics, and textiles. Even the children's art programs became infused with community ideals. Art Director Emily Edwards instructed this painting class not to paint what they saw but rather to envision the alley as if it were clean. (JAMC 2036)

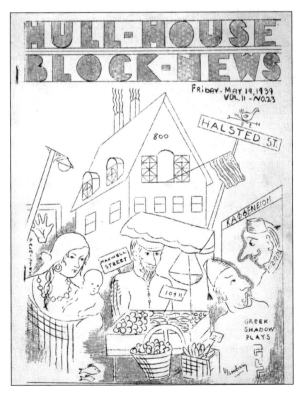

The theater production *Halsted Street*, written by cast members and directed by Jess Ogden in 1939, incorporated a determination to address local issues, to involve large numbers of neighborhood residents, and to integrate the work of several Hull-House arts departments. With a cast of over 150, this original production used a multi-level stage to tell the story of everyday life for the residents of Halsted Street. Hull-House artist Michael Gamboney illustrated the play for the cover of the *Hull-House Block News*. (HHA)

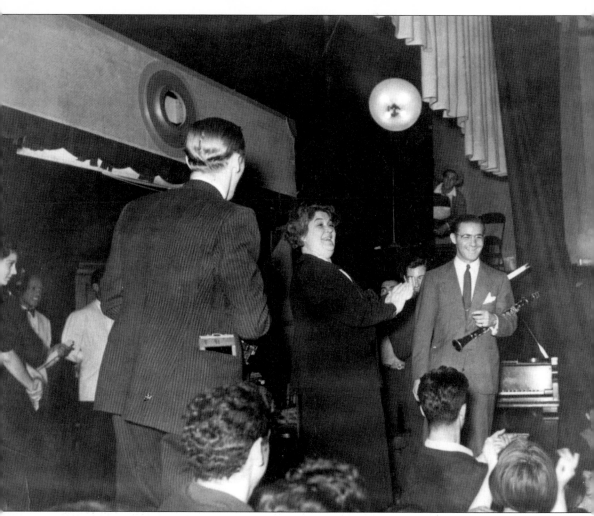

Other arts programs also became more inclusive. The Music School dropped its audition requirements to open its program to all interested students. Attendance soared as recreational music classes supplemented more formal training. In 1938, former music student Benny Goodman gave a benefit for the settlement and then returned to the neighborhood to play for a packed crowd in Bowen Hall. Over 1,500 children 'swung' with Goodman, pianist Teddy Wilson, and drummer Gene Krupa. (JAMC 396)

Eight

NEW FACES
AT HULL-HOUSE

In August 1945, Executive Director Russell Ward Ballard compiled a sample list of telephone inquiries received at Hull-House over the month. Among the questions asked of Hull-House staff were:

" My husband ran away with another woman; will you help me find him?"
"I have a sick dog; can I bring it over there for your doctor to look at?"
"I just came to town; could you tell me where the Hungarian neighborhood is?" and
"My unmarried sister is going to have a baby; we don't want our family to know about it, will you advise us what to do?"

Despite the upheaval within the settlement administration and the changing nature of the neighborhood, one thing is clear: Hull-House remained a place for people to take their problems when they had nowhere else to turn.

In the post-war period, Hull-House tried to create a welcoming space for its neighbors—many of whom were now second-generation Americans, Mexican and Puerto Rican migrants and African Americans. While continuing to offer classes and social activities, Hull-House's methods evolved to reflect the changing nature of social work. Under Director Russell Ward Ballard, the settlement hired a greater number of graduates of university social work programs. Gradually, paid, professionally trained social workers began to replace the amateur, volunteer residents who had run the settlement house's services for half a century.

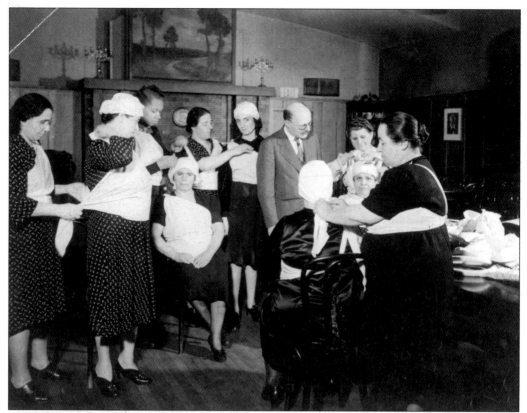

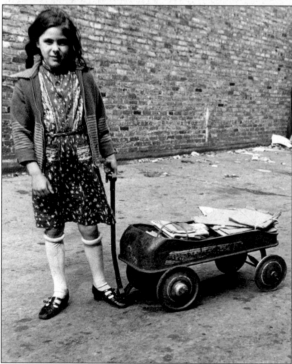

When the United States entered the Second World War in 1941, the attentions of Hull-House residents and neighbors turned to helping the war effort and surviving the war-time economy. Neighborhood women came to Hull-House to take classes in first aid and home nursing. (JAMC 634)

Hull-House added two new activities for youth as a result of the war: classes in model airplane making and a campaign to salvage waste paper. The settlement housed the community headquarters of the Office of Civilian Defense and several Hull-House residents became active in its activities, including Head Resident Charlotte Carr who served as Chairman of Community Morale. (Kirkland)

Many more Hull-House residents, volunteers, and neighbors enlisted in the military and served overseas. Bowen Country Club alumnus Guido Tardi began the "Chain Around the World"—a chain letter that connected BCC alumni serving in the military with each other and with the camp. (JAMC 4821)

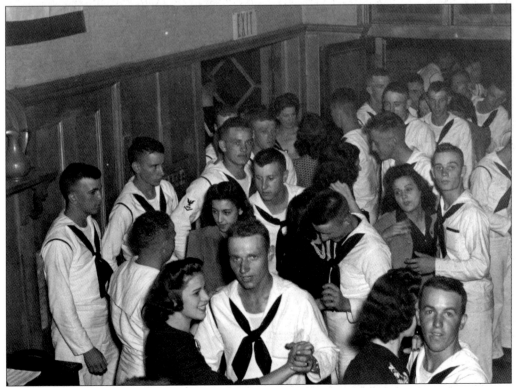

At Hull-House, club-members collected cigarettes to send to Hull-House service men overseas and entertained military personnel on furlough. (JAMC 341)

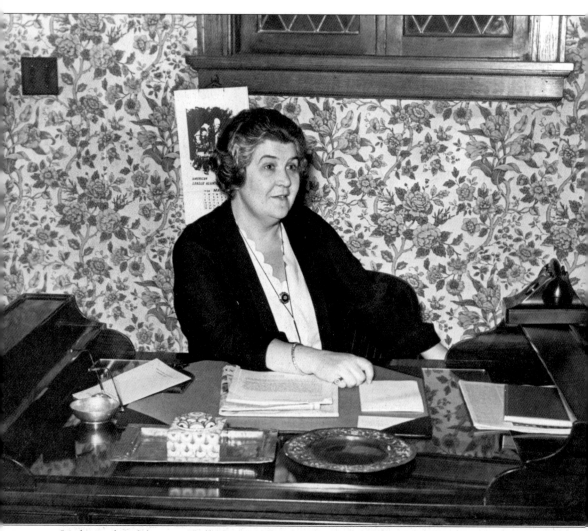

In the midst of the war, Hull-House suffered even greater upheaval with the resignation of head resident Charlotte Carr in 1942. "Hell, I was fired," claimed Carr, who shocked many Hull-House traditionalists by smoking, drinking, and turning Jane Addams' bedroom into her office, pictured here. (JAMC 3425)

Carr, who had feared that Hull-House would turn into a shrine to Jane Addams, had taken a distinctly different approach to her work at Hull-House. Carr thought of herself as a labor leader rather than a social worker and had focused her energies on political and labor organizing in the neighborhood. This did not sit well with the Board of Trustees and in late 1942, they decided to part ways. (JAMC 107)

In 1943, Carr was replaced by Russell Ward Ballard, the first man to hold the position of head resident. Ballard, who considered himself a social worker in the tradition of Addams, sought to balance the need for community organizing with building the kind of personal relationships with neighbors that had characterized Jane Addams' tenure as head resident. (JAMC 233)

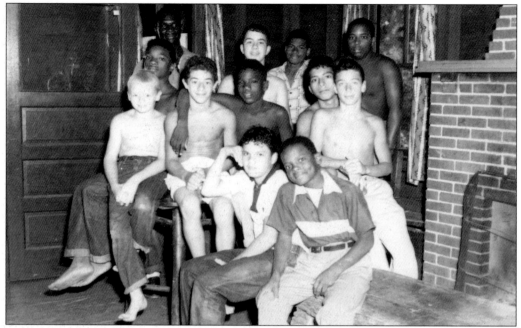

With the conclusion of the war in 1945 and peace between the head resident and the Board of Trustees at Hull-House, the settlement was again able to focus on reaching out to local communities in need. Throughout the 1940s and 1950s, increasing numbers of African Americans joined their neighbors in clubs, at social events, and at the Bowen Country Club, pictured here. (JAMC 4545)

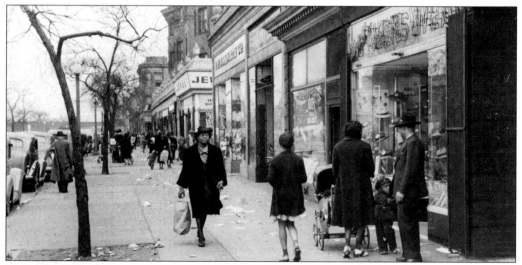

For some African American participants at Hull-House, merely walking from their homes to the settlement house could be dangerous. On March 28, 1952, Russell Ward Ballard reported to the Board of Trustees that one of the Hull-House workers, a young white man, had been stabbed while escorting a group of African American boys to their homes. "This he had been doing for some time," reported Ballard, "because the boys reported that a gang of older white boys had been molesting them and calling them names." The assault appeared to have been perpetrated by the same white gang. (Library of Congress)

In response to the aftermath of the war, Hull-House also extended its services to help victims of war in Chicago. In the early 1950s, the Near West Side was home to many displaced persons from Latvia. In addition to providing social services, Hull-House sponsored Latvian concerts and theatrical performances. (JAMC 581)

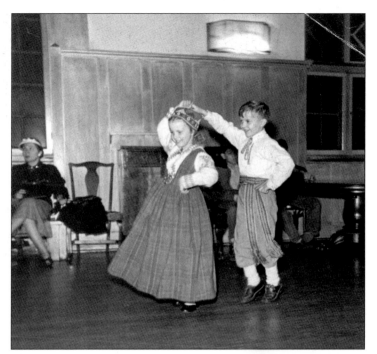

The Near West Side remained a constantly shifting neighborhood through the 1950s. After the war, Puerto Rican families began moving into the Hull-House neighborhood. In 1953, Hull-House hired a Puerto Rican social worker to work with this community. She reported that the two most important problems facing the settlement's Puerto Ricans were finding employment and decent housing in the run-down Near West Side. (JAMC 3265)

The profession of social work had evolved considerably since the first days of Hull-House, when settlement leaders were among those credited with founding the profession. At Hull-House and other settlements, paid, professional graduates of social work schools increasingly worked alongside untrained volunteer residents. (JAMC 225)

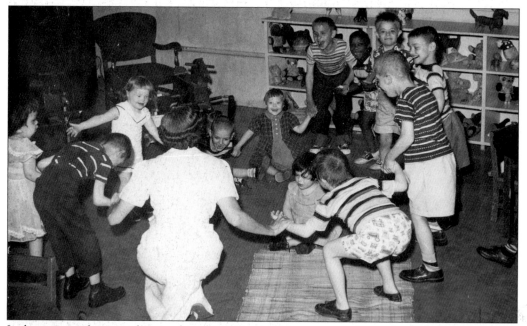

In keeping with its tradition of creating pioneering programs for underserved communities, Hull-House worked with the mentally and physically disabled in the late 1940s. Social worker Bertha Schlotter brought a long career's worth of experience to Hull-House's Retarded Children's Training Center. Influenced in part by former resident Neva Leona Boyd, Schlotter worked as an occupational therapist for many years at the Chicago State Hospital (pictured here) before coming to Hull-House. (Schlotter)

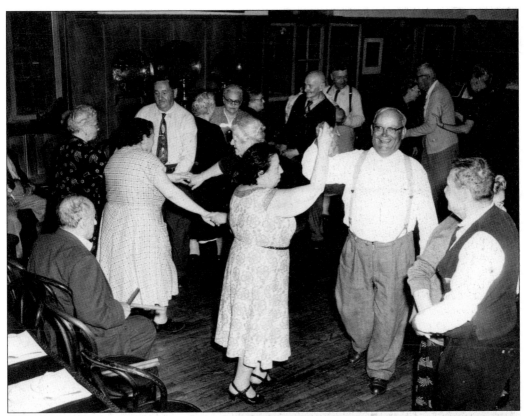

Relieving the isolation often experienced by the elderly was a priority for Jane Addams and Ellen Gates Starr from the first days of Hull-House. In this tradition, Hull-House expanded its programs for senior citizens in the post-war period. (JAMC 3776)

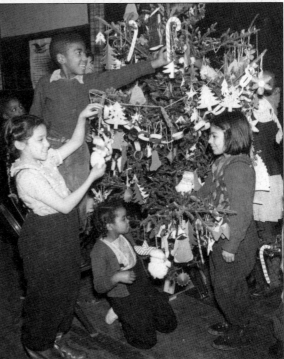

While Hull-House returned to the serious business of helping its neighbors after the war, it also returned to the business of having fun. As they did in Jane Addams' day, Hull-House residents continued to host distinguished visitors, to throw parties for their neighbors, and celebrate holidays. Here, children decorate the game room for Christmas c. 1954. (JAMC 105)

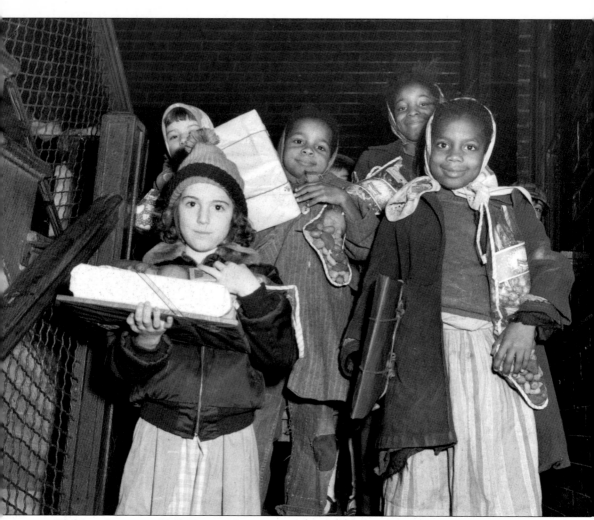

Children leaving a Hull-House Christmas party with packages and stockings are pictured here c. 1953. (JAMC 2180)

In 1944, Hull-House volunteer Lyman Carpenter started the "Zoodeo" at Hull-House: "a menagerie in which many of the denizens romp in unrestricted rodeo style." Located in a fourth-floor clubroom, the Zoodeo housed rabbits, snakes, white mice, prairie dogs, raccoons, two monkeys, and a variety of fish. (Kohn)

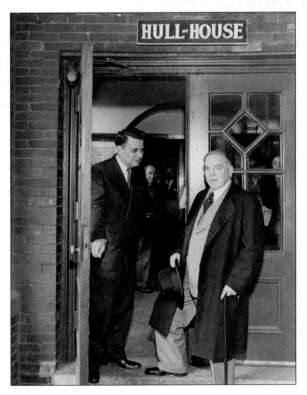

Hull-House continued to be a popular stop for visitors to Chicago. Here Canadian Prime Minister William Lyon McKenzie King visits Hull-House on his way to San Francisco for the founding conference of the United Nations. During his visit, King recalled his days as a Hull-House resident in 1896 and visited his old third-floor bedroom. (JAMC 3919)

Many other visitors came for the 50th anniversary of Hull-House in 1940. In addition to a banquet and reunion, Hull-House celebrated with a street carnival for neighbors. (JAMC 3903 and 4237)

Nine

HULL-HOUSE
CLOSES ITS DOORS

While Hull-House was busy adjusting to the changing needs of its neighbors in the post-war period, its leaders were also dealing with the vexing problem of settlement finances. In addition to funding programs and a paid staff, the settlement also had to pay for the upkeep and modernization of the settlement buildings, most of which were over a half century old. Increasingly, the settlement buildings were a drain on Hull-House's already tight budget.

The 1950s also witnessed the launch of the city of Chicago's urban renewal initiatives aimed at improving housing conditions and revitalizing the economically depressed areas of the city. Much of the area surrounding Hull-House was condemned by city officials and was slated for land clearance. Originally, the area was scheduled to be rebuilt as housing and Hull-House sponsored the Near West Side Planning Board's attempts to involve citizen participation in planning the future of the neighborhood. However, in 1960, the city proposed the Harrison–Halsted neighborhood as the site for the new Chicago campus of the University of Illinois, then located in inadequate facilities on Navy Pier.

Hull-House leaders, who had worked with city officials in persuading their neighbors to cooperate in the land clearance scheme and to participate in planning activities, were dismayed to learn that their neighbors would now be dislocated. However, in the end, Hull-House officials did not fight the decision to locate the university on the Near West Side and in 1963, sold the Hull-House complex to the city of Chicago for $875,000. For the Hull-House Board of Trustees, this was a pragmatic decision. In the late 1950s, settlement leaders realized that fewer of the program participants lived in the immediate neighborhood. Instead, people traveled from around the city to attend Hull-House activities. The city of Chicago might be better served, thought many Board members, by a series of neighborhood centers throughout the city.

Hull-House neighbors and supporters throughout the country were less complacent. Neighbors staged protests and supporters wrote angry letters. Long-time Hull-House resident Jessie Binford worked with neighbor Florence Scala in the most vigorous effort to prevent the sale of Hull-House. Their organization filed legal suits against the university and the city, culminating in a Supreme Court decision in favor of the university in 1963, effectively ending their fight to save Hull-House from the wrecking ball.

Appearing on a panel of settlement leaders in 1929, Jane Addams was asked to reflect on what she would have liked to have done differently in her administration of Hull-House. She responded, "We have connected with Hull-House now a good many buildings, and all of a sudden they all seem to need new roofs, and new plumbing, and the brick-work needs painting on every wall. I think if I had it to do over again I should have fewer buildings." (Kirkland)

By the post-WWII period, maintenance of the settlement complex was becoming increasingly burdensome on the finances of the settlement house. In 1956, President of the Board Burke Williamson chastised the settlement house for repeatedly dipping into the principle of the endowment fund to meet operating expenses. (JAMC 164)

Occasional disasters, such as the 1957 fire in the Hull-House Theater, took their toll on the budget. The fire destroyed Hull-House's prized pipe organ, donated to the settlement by Mary Rozet Smith. (JAMC 4318)

The aging buildings of the Bowen Country Club also required expensive maintenance and upgrading. For many years camp staff had to repair the damage done by violent summer and winter storms. Here, a tree has blown into the BCC pool. (JAMC 4527)

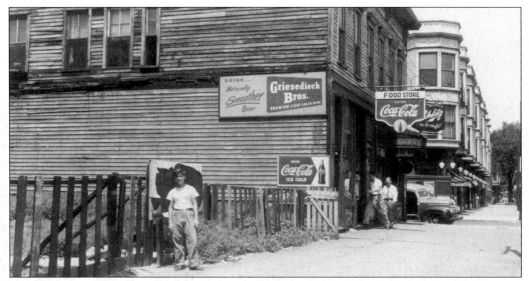

Neighborhood housing, much of it as old as Hull-House, had fared much worse than the settlement complex. In 1959, the *Chicago Daily News* reported conditions in the Near West Side in terms that Jane Addams could have used 70 years earlier. "Look down and you see garbage-strewn streets, gaping slums, big-eyed kids shuffling among the fishbones and filth in soiled alleys. Even some manhole covers are missing. [The neighborhood] is being torn down and rebuilt. Parts of it look as if it had been bombed." (JAMC 3156)

Head Resident Russell Ballard believed that neighborhood residents would be more interested in improving local conditions if they were actively involved in the process of planning and campaigning for improvements. To that end, Hull-House worked with the West Side Community Committee of Chicago to form the Near West Side Planning Board in 1949, seen here meeting in the basement of Our Lady of Pompeii Church. Its stated purpose was to serve the people of the Near West Side by planning and carrying out a program of conservation, rehabilitation, and development of the neighborhood based on the advice of the area's institutions and residents. (IAC 189.14)

After working with city officials in an attempt to revitalize the residential neighborhood of the Near West Side for over ten years, the Planning Board was shocked to learn that the city of Chicago had proposed their very neighborhood for the site of the new Chicago campus of the University of Illinois. Neighborhood residents were even more appalled when the Hull-House complex failed to fight the decision to clear the area, and agreed to sell the settlement complex to the city. Mayor Richard J. Daley, seen here meeting with members of the Hull-House Board, personally championed the relocation of the university to the Near West Side. (JAMC 3922)

A group of neighborhood residents, including many members of the Near West Side Planning Board decided to fight the city's decision. Long time Hull-House resident Jessie Binford, pictured here with some Hull-House children, joined neighborhood resident Florence Scala in the fight to save Hull-House. In addition to letter-writing campaigns and marches, the Harrison-Halsted neighborhood group took their fight to the courts, where they cited unfairness in the condemnation proceedings. (JAMC 391)

Feeling abandoned by local politicians, Florence Scala herself ran as an aldermanic candidate. It was a tactic reminiscent of the Hull-House pioneers, and like the early Hull-House residents, Florence Scala lost her bid for a seat on the City Council. In 1963, Scala and her organization suffered their final defeat when the Illinois Supreme Court rejected their claim. (Scala)

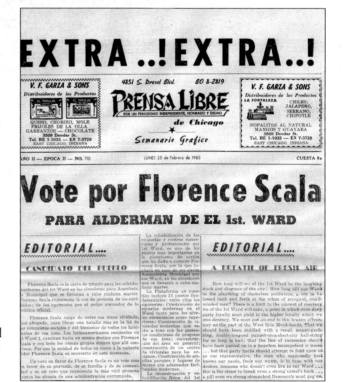

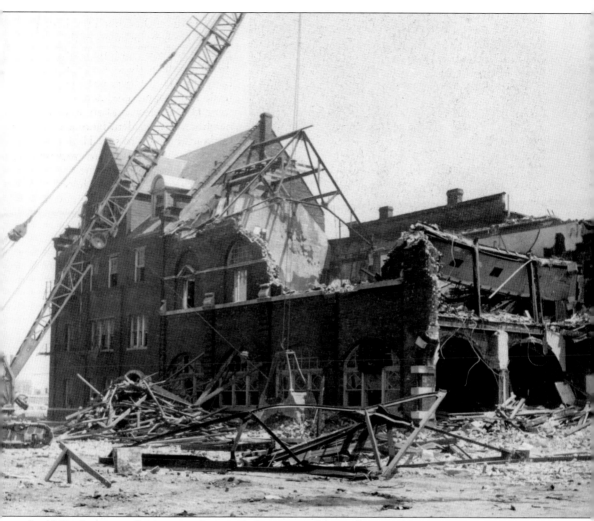

In 1963, former settlement resident and photojournalist Wallace Kirkland returned to Halsted Street to photograph the demolition of the famous settlement house. People across the nation mourned the loss of the symbolic building and its neighborhood. At home in Chicago, journalist Studs Terkel remarked, "When they destroyed the old Hull-House area with its polyglot talkers and poly-cultures and the old world and the new world breathing together, it was done in the name of a university and a city. Not to mention the names of cement contractors and brokers and all sorts of breakers." (JAMC 922)

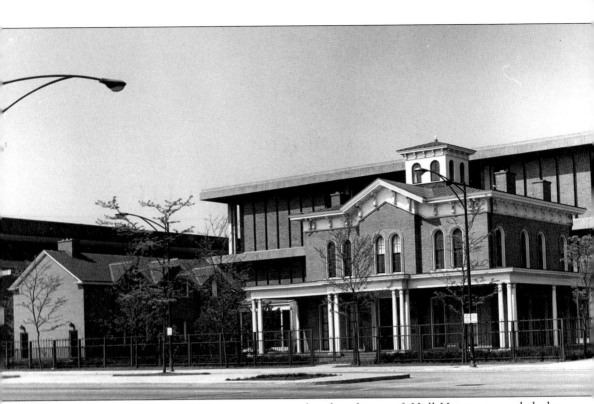

The citywide and nationwide attention to the demolition of Hull-House persuaded the university to preserve two of the original Hull-House buildings. The original Hull mansion (pictured here in the foreground) and the Residents Dining Hall (left) were restored by the University of Illinois. The Hull mansion was subsequently designated a National and a Chicago Historic Landmark. The two buildings are the current home of the university's Jane Addams Hull-House Museum, which seeks to commemorate the life of Jane Addams and to interpret the history of the settlement house to the public. (JAMC 2685)

Epilogue
MORE THAN THE
BUILDINGS

After moving from its Halsted Street location, the Jane Addams Hull House Association set out to demonstrate that its vitality was not tied to the buildings where its programs had resided for over 70 years. By absorbing former settlements and creating new neighborhood centers, the organization reached out into several metropolitan neighborhoods. Some aspects changed. Staff members no longer lived in the buildings—a defining aspect of settlement life. Beginning with an influx of federal funds during the War on Poverty, Hull House Association increasingly relied on federal grants and programs, rather than personal fundraising efforts. Finally, programming changed to reflect the recognition of urban issues such as drug abuse, homelessness, domestic violence, teenage pregnancy, and an expanding senior citizen population. Yet, the past was not abandoned. Arts programming, including a nationally known experimental theater program under the direction of Robert Sickinger, and traditional settlement issues such as employment, housing, and research received support.

Today, the Jane Addams Hull House Association's mission encompasses both programs and advocacy. Three community centers and numerous satellite programs on the north, west, and south sides of Chicago offer innovative programs such as Neighbor to Neighbor—a foster care program that keeps siblings together within their community—and New Directions, which teaches skills for independent living to young adults. In 2002, the Human Relations Foundation/Jane Addams Policy Initiative recommitted the organization to research into systemic causes of contemporary problems. Through these and other innovative endeavors, Jane Addams Hull House Association continues its commitment to neighborhood-centered programming and social policy reform. President and CEO Clarence N. Wood asserts that the organization continues to change "to creatively meet the needs of families who have made Hull House more than the buildings we occupy."

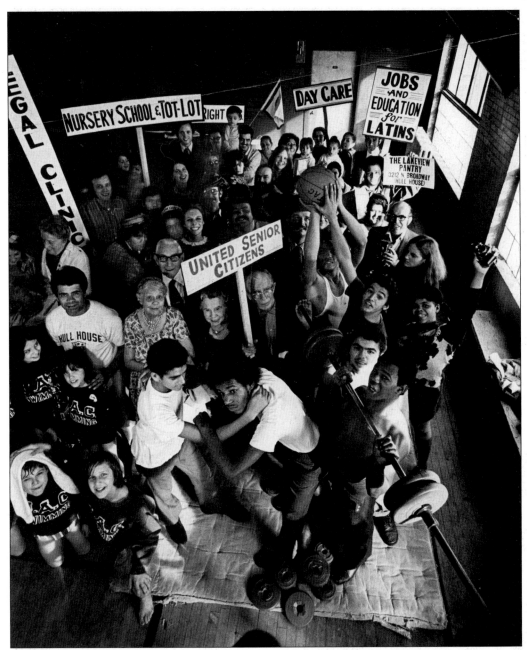

In the 1960s, the Jane Addams Center at 3139 North Broadway became the administrative center for Hull House Association. When the center opened in the Lakeview neighborhood in 1963, the area suffered from many of the problems that had plagued the original Hull-House community. Other centers opened on the city's north and south sides with their own directors and staff. Each designed programs to address the specific needs of its neighborhood. They included childcare, arts classes, experimental theater, community development, and employment assistance. Today, Jane Addams Hull House Association has reorganized into three neighborhood centers: Uptown Center, Parkway Community House, and Le Claire Hearst Community Centers—serving over 60,000 people in the west, north, and south sides of the city. (HHA)

The above "before" and "after" photographs illustrated a brochure for the Housing Resource Center, which opened in 1975 in the Uptown community. Committed to neighborhood revitalization, the Housing Resource Center worked with landlords and tenants to preserve and improve existing affordable housing. Today, the Housing Resource Center operates two community-based management agencies that oversee more than 1,400 units of family and senior housing for the Chicago Housing Authority and provide social services for residents. (HHA)

The Retired and Senior Volunteer Program (RSVP) has been matching seniors with appropriate volunteer work for over 25 years. In 2003, over 1,000 seniors volunteered at more than 200 non-profit organizations. Senior Services programs also include Baby Brigade, which brings together nursing home residents and children, Grandma, Please! which trains seniors to answer calls from children home alone after school hours, and Respite Central, which assists caregivers of the elderly. (JAMC 5402)

Jane Addams Hull House Association offers several programs designed to foster independent living by teaching job and life skills. The Work First program provides resources such as job referrals, placement assistance, and individual counseling to assist adults receiving government assistance in finding full-time employment. (Jane Addams Hull House Association)

The Family Literacy Program encourages families from low-income communities to work together to improve reading skills in order to enhance employability for parents and improve school performance for children. (Jane Addams Hull House Association)

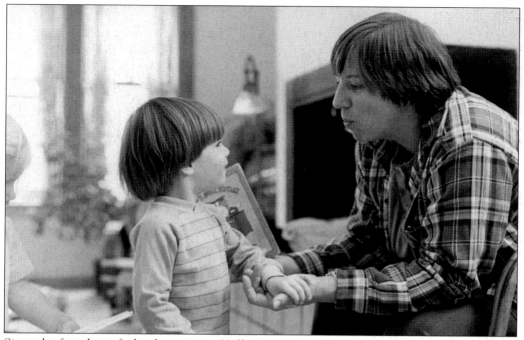

Since the founding of a kindergarten in Hull-House's first year, the organization has recognized the special needs and problems facing women. In 2003, over 75 percent of the people served by Jane Addams Hull House Association were women and girls. Programs include job skills training, the Domestic Violence Court Advocacy Program which assists women who pursue criminal charges for battery, daycare provider training, and the provision of approximately 925,000 hours of daycare for children of working mothers. (HHA)

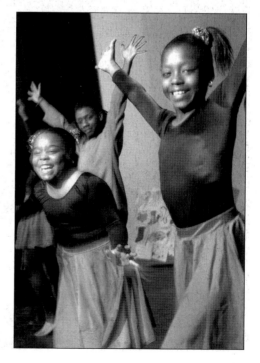

Two arts centers on the north and west sides of Chicago offer classes for children who may not have art education in their schools. The centers work with the Chicago Park District and local schools. Above, young girls from a ballet class perform at the Duncan YMCA on Chicago's West Side. The arts programs form a vital component of Jane Addams Hull House Association's continuing commitment to address basic needs but also those of the spirit. (Jane Addams Hull House Association)

Bibliography

Addams, Jane. *The Second Twenty Years at Hull-House*. New York: Macmillan Co., 1930.
———. *The Spirit of Youth and the City Streets*. 1909. Reprint. Urbana: University of Illinois Press, 1972.
———. *Twenty Years at Hull-House*. 1910. Reprint. Urbana: University of Illinois Press, 1990.
Brown, Victoria. *The Education of Jane Addams*. Philadelphia : University of Pennsylvania Press, 2004.
Bryan, Mary Lynn McCree and Allen F. Davis, eds. *One Hundred Years at Hull-House*. Bloomington: Indiana University Press, 1990.
Davis, Allen. *American Heroine: The Life and Legend of Jane Addams*. Chicago : Ivan R. Dee, 2000.
Davis, Allen. *Spearheads for Reform: The Social Settlements and the Progressive Movement, 1890-1914*. Oxford: Oxford University Press, 1967.
Ganz, Cheryl R. and Margaret Strobel, eds. *Pots of Promise: Mexicans and Pottery at Hull-House, 1920-40*. Urbana: University of Illinois Press, 2004.
Hull-House, Residents of. *Hull-House Maps and Papers*. 1895. Reprint. New York: Arno Press, 1970.
Jackson, Shannon. *Lines of Activity: Performance, Historiography, Hull-House Domesticity*. Ann Arbor: University of Michigan Press, 2000.
Lasch-Quinn, Elisabeth. *Black Neighbors : Race and the Limits of Reform in the American Settlement House Movement, 1890-1945*. Chapel Hill: University of North Carolina Press, 1993.
Linn, James Weber. *Jane Addams: A Biography*. 1935. Reprint. Urbana: University of Illinois Press, 2000.
Lissak, Rivka Shpak. *Pluralism and Progressives: Hull House and the New Immigrants, 1890-1919*. Chicago: University of Chicago Press, 1989.
Pacyga, Dominic and Ellen Skerrett, eds. *Chicago, City of Neighborhoods : Histories & Tours*. Chicago Loyola University Press, c1986.
Polacheck, Hilda Satt. *I Came a Stranger: The Story of a Hull-House Girl*. Urbana: University of Illinois Press, c. 1989.
Polikoff, Barbara Garland. *With One Bold Act: The Story of Jane Addams*. Chicago : Boswell Books, 1999.
Schultz, Rima Lunin, ed. "Urban Experience in Chicago: Hull-House and its Neighborhoods 1889-1963." University of Illinois at Chicago: http://www.uic.edu/jaddams/hull/urbanexp/
Trolander, Judith Ann. *Settlement Houses and the Great Depression*. Detroit: Wayne State University, 1975.

The Jane Addams Memorial Collection at the University of Illinois at Chicago, Special Collections contains a number of manuscript collections documenting the history of Hull-House and other settlement houses in Chicago.